IMAGES
of America

NEW CARLISLE

To Katy,
Hope you enjoy!
Love,
Dana

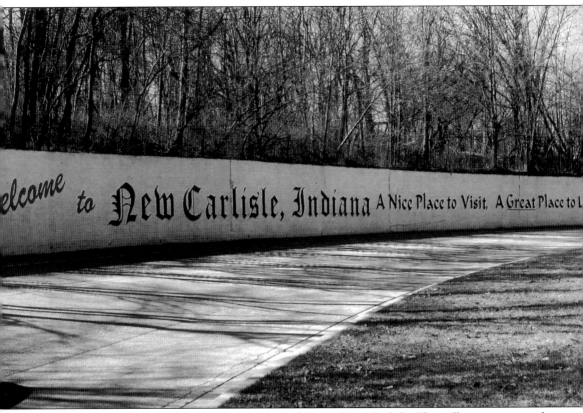

The viaduct wall is a local landmark that greets visitors to New Carlisle. The wall was constructed in 1925 as an improvement to the Lincoln Highway. Over the years, the wall has featured various images and artwork painted by local artists. (Historic New Carlisle.)

ON THE COVER: Davidson and Porter's Dry Good Store, located at 129 East Michigan St., featured a variety of items for sale including hats, shoes, and clothing. A dentist advertised his services on the second floor. (Historic New Carlisle.)

IMAGES
of America

NEW CARLISLE

Dana Groves for Historic New Carlisle, Inc.

ARCADIA
PUBLISHING

Published by Arcadia Publishing
Charleston SC, Chicago IL, Portsmouth NH, San Francisco CA

Printed in the United States of America

Library of Congress Control Number: 2009943868

For all general information contact Arcadia Publishing at:
Telephone 843-853-2070
Fax 843-853-0044
E-mail sales@arcadiapublishing.com
For customer service and orders:
Toll-Free 1-888-313-2665

Visit us on the Internet at www.arcadiapublishing.com

This book is dedicated to anyone who has ever called New Carlisle home in celebration of the town's 175th anniversary.

CONTENTS

ACKNOWLEDGMENTS

The prime motivation in publishing this book was the celebration of New Carlisle's 175th Anniversary in 2010. Through the use of images, I hope that I have captured the special qualities that New Carlisle and its people possess.

I want to thank Historic New Carlisle, Inc. for allowing me to take on such a project. Many of the photographs used in this book came from Historic New Carlisle's (HNC) archival collection. The archival collection includes photographs, newspapers, and historical information that have been donated by people in the community over the last 20 years.

Several individuals came forward to share their personal photographs making this book possible. I thank everyone who allowed me to use their photographs and offer my appreciation to those whose photographs were not ultimately chosen. I called upon many people to help identify individuals in the images used for the book. I greatly appreciate everyone's willingness to help.

I cannot thank Mary Ann Swope and Paul Wogatzke enough for their help in putting this book together. Mary Ann helped to proofread and edit my rough drafts and provided an immense amount of historical information as well as support and encouragement along the way. Paul scanned the images used in the book and many more that never made the cut. I can't thank him enough for all the time he saved me during this process. Thank you both!

INTRODUCTION

Before the first white settlers arrived on the Terre Coupee prairie, the land was inhabited by tribes of Native Americans. A treaty signed on October 16, 1826, between Gov. Lewis Cass, Gov. James B. Ray, Gen. John Tipton, and the chiefs and warriors of the Potawatomi Indian tribe forced the Native Americans to cede their lands to allow for white settlement. The treaty gave 160 acres to each Native American who had attended the Carey Mission School. The school was located near Niles, Michigan, and sought to assimilate the Native Americans to the white man's culture. Potawatomi Indian trader Lazarus Bourissa was one of the men who received land that is now New Carlisle. He lived in a double-pole log cabin that also served as his trading post on the northwest corner of Michigan and Cherry Streets. The area was known at the time as Bourissa Hill.

In 1835, Richard Risley Carlisle came to the area and purchased Bourissa's 160 acres for $2,000. Carlisle platted the town on August 15, 1835. The town came to be known as Carlisle Hill and was incorporated in 1866 when it was officially renamed New Carlisle. The original plat included the Michigan Road, which was named Michigan Street as well as Race, Arch, Filbert, Front, and Chestnut Streets. Richard Risley Carlisle was born in 1814 in Burlington County, New Jersey. Carlisle only lived here from 1835 to 1840. He traveled extensively all over the world and was a famous circus and theatrical entertainer. He often performed with his two sons, John and Henry. Carlisle performed in Japan and throughout Europe, and one of his circus acts, named the "Risley" act, was listed in the *Guinness Book of World Records*. This juggling act was performed with his sons.

Olive Township was organized in March 1832. The township was named after Olive (Stanton) Vail who, along with her husband, Charles, had settled on the Terre Coupee prairie. The construction of the Michigan Road in the mid-1830s opened up the area for settlement. The Michigan Road was supposed to be a direct route from Madison, Indiana, to Lake Michigan in Michigan City. When surveyors came to the Kankakee marshes, it was impossible to build a road, so the route was redirected to South Bend and continued west through New Carlisle and on to Michigan City. The road was built through St. Joseph County in 1834 and became a major transportation route. Many small villages and towns began to develop along the route. The Hotel Carlisle was built in 1838 and served as the stagecoach stop along the road.

Early settlers came from New York, New Jersey, Ohio, southern Indiana, and Kentucky. They were attracted by the rich soil of the Terre Coupee prairie, a vast, flat prairie east of the town of New Carlisle. The pioneers cleared the land, built their crude log homes, and planted crops. Changes came quickly with the coming of the Lake Shore Railroad. The railroad was built in 1852 through New Carlisle, bypassing several of the other towns such as Hamilton, Plainfield, Richardson, and New Palestine. Before the railroad, Hamilton had a higher population than New Carlisle, but the railroad changed that and Hamilton, along with the other small towns, virtually disappeared.

New Carlisle, the little town on the hill, would grow and prosper with the arrival of the railroad. The simple cabins were now replaced with fine wood and brick residences. Lumber and a wide variety of building materials was now easily accessible and more affordable. New homes and businesses were built in the popular styles of the day such as Italianate, Queen Anne, and Gothic Revival. New businesses flourished, such as banks, dry goods, grocery stores, drug stores, millinery and clothing stores, doctors, dentists, barber shops, and hardware and furniture stores. Other businesses included a livery, blacksmith shop, harness shop, and flour and saw mills.

New Carlisle has always been situated on major transportation routes. After the stagecoach days and the railroad, two interurban lines were established in 1907. In 1908, the South Shore Railroad was constructed and New Carlisle became a regular stop from South Bend to Chicago. The first transcontinental highway, the Lincoln Highway, was conceived in 1912 by a group of car enthusiasts and automobile manufacturers. The original route of the Lincoln Highway followed Michigan Road through New Carlisle, benefitting the town from the traffic that the improved road created. In 1928, Lincoln Highway was moved to U.S. 30.

Religion and education have always been important aspects of people's lives in New Carlisle. Early settlers held church services in their homes until they were able to build new churches in which they could pray and expand their religious beliefs. We are fortunate to have many of those original churches standing and some still in use today. Education also continues to be a top priority for the community. At one time, Olive Township had 13 district schools that provided education to children living outside of the town of New Carlisle. Those living in the town attended the Carlisle Collegiate Institute. By the early 1950s, the last district school had closed and all children went to the New Carlisle schools.

Community groups and organizations have played a significant role in the betterment of the community. These organizations and the people involved in them have served as the backbone of the community, always willing to help where needed. Support has come in many forms for the local schools, parks, fire department, needy families, and the list goes on.

Over the years, New Carlisle has grown from a mere village to a thriving town. New businesses, homes, schools, a library, and the influx of new people have all contributed to the wonderful quality of life that the New Carlisle area provides. The pride and hard work of the people who have called the New Carlisle area their home is evident. The town of New Carlisle and surrounding area is very fortunate to have retained many of its historic homes, buildings, and religious structures as well as its parks and farmland. The citizens, past and present, have worked to maintain and preserve these standing reminders of the community's rich history.

One

ON THE PRAIRIE

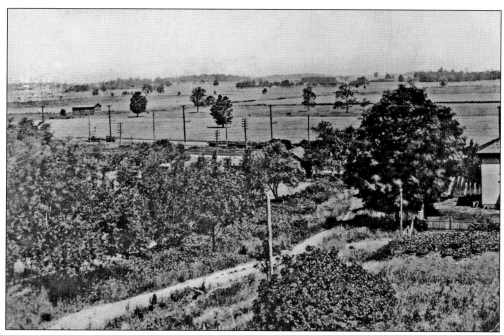

A picture postcard shows the view from New Carlisle overlooking the Terre Coupee prairie. Around 1830, the first white settlers came to the prairie finding the farmland rich and fertile. Early families included the Garwoods, Hubbards, Egberts, Nickersons, Garouttes, Reynolds, Ransteads, Druliners, and Rushes. The old Sauk Trail, known as the Chicago-Detroit Road or Chicago Trail, as well as the Michigan Road, helped to open settlement on the prairie. (HNC.)

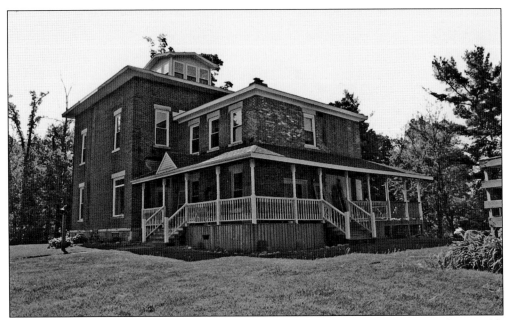

The John Reynolds homestead was constructed in 1860 on the Chicago-Detroit Road. Reynolds came to the area at the age of 15 and learned the blacksmith trade. He went on to control several mercantile businesses and invested and contracted with the railroad to build ties, rails, bridges, and culverts. By 1860, he was the wealthiest man in the state of Indiana and at one time was a state senator. (Photograph by Everett Dobbins.)

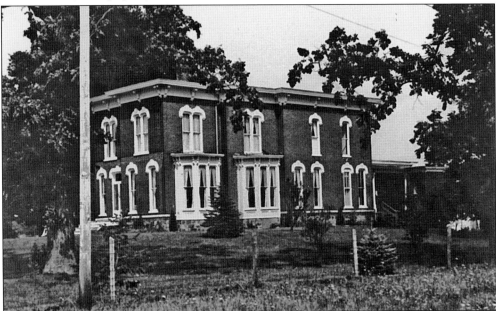

The James Reynolds two-story Italianate home was built just south of Hamilton in 1861 on Walnut Road within a mile of his brother John. From a very poor family near Richmond, Indiana, both brothers became prominent citizens of St. Joseph County. James Reynolds came to the Hamilton area between 1831 and 1833. He farmed and operated stores in Buchanan and Dayton, Michigan, and was the president of Buchanan's First National Bank. (HNC.)

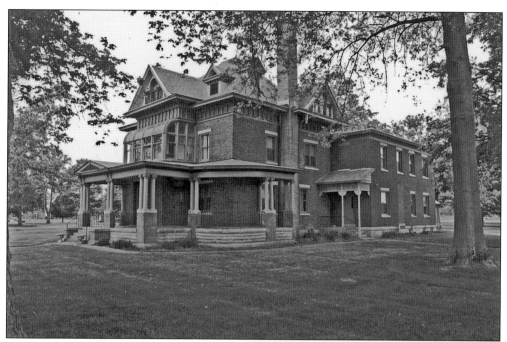

The Hubbard Homestead was built by early settler Jonathon Hubbard along the Chicago-Detroit Road. In 1836, Hubbard came to the prairie and purchased 320 acres from Samuel Garwood. He platted the town of Terre Coupee or "Hubbard Town," as it was also called, and later renamed Hamilton. Hubbard was a farmer and along with his son Ransom developed the farm to include 700 acres. Jonathon Hubbard died in 1861. (Photograph by Everett Dobbins.)

Haven Hubbard was one of three sons born to Ransom Hubbard in 1852. Haven was educated at the University of Michigan. He married Arminia Hoffman in 1909, and they lived in the Hubbard Homestead built by his grandfather. Haven always had a desire to minister to the needs of older people, but he never realized his plans before his death in 1916. Arminia acquired the home and farm, which included over 700 acres. (Courtesy of Hamilton Communities, Inc.)

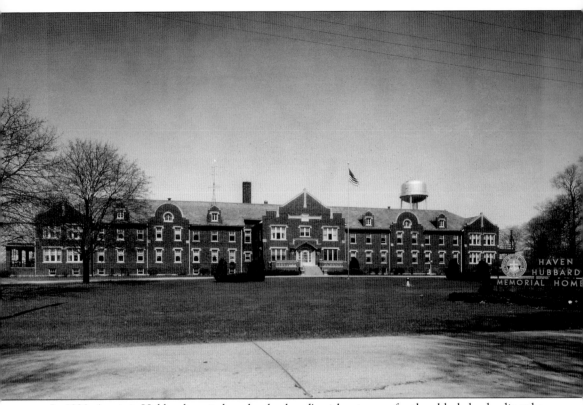

In 1920, Arminia Hubbard carried out her husband's wishes to care for the elderly by deeding the Hubbard farm of over 700 acres to the local Evangelical church for the purpose of erecting a home for the elderly. The Haven Hubbard Memorial Old People's Home was built in 1922 and formally dedicated on May 5, 1923. The building was constructed in the shape of a T and was made of Saraband Chinchilla brick with limestone trim and a slate roof. The interior trim was made of southern gum with floors of hard maple. The building consisted of administrative offices, guest rooms, dining hall, a chapel, sun parlors, and open-air verandas. The home was a working farm, raising its own food and crops. Residents were encouraged to help with the chores and farming operations. (Courtesy of Hamilton Communities, Inc.)

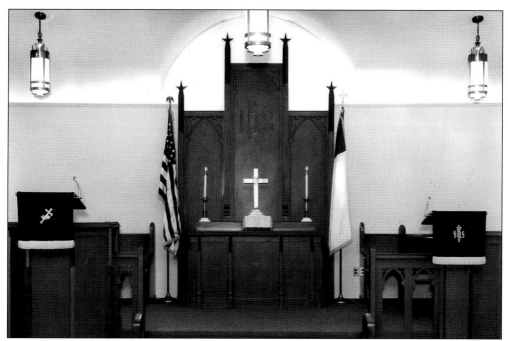

The chapel located on the second floor of the Haven Hubbard Memorial Old People's Home provided church services and Sunday school lessons. A victory celebration took place in the chapel on September 13, 1945, marking the end of a long struggle to wipe out all debt. The chapel was later remodeled in 1950 and dedicated as the Arminia Hubbard Memorial Chapel. (Courtesy of Hamilton Communities, Inc.)

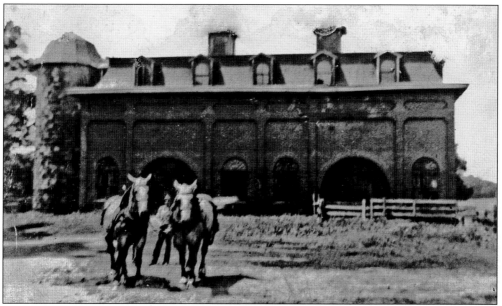

Dick Brewer is pictured in front of the Haven Hubbard Dairy Barn driving his team of horses at the age of 16. The Brewer family moved to Hamilton in 1936, and Dick's father worked as the manager of the Haven Hubbard farm. Cap is the horse on the left, weighing in at 2,100 pounds. Cap's mother, Fanny, is the horse on the right, weighing in at 1,900 pounds. (Courtesy of Dick Brewer.)

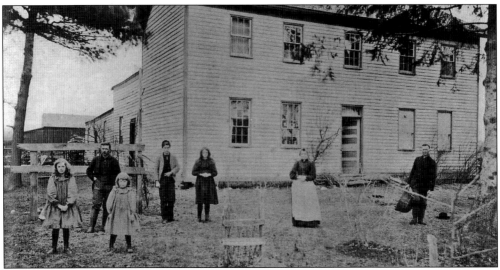

Ezekiel Whitlock's Tavern, serving travelers on the Chicago-Detroit Road, was constructed around 1837 by Ezekiel Whitlock and purchased later by Theodore Borden, who married Whitlock's daughter, Eliza. Pictured in 1895 are, from left to right, Maude Borden, Andrus Borden, Carmen Borden, Clifford Borden, Grace Borden, Blanche (Bulla) Borden, and unidentified. Anna (Borden) Proud was born to Theodore and Eliza in the tavern in 1868. Anna inherited her birthplace, which came to be known as the Proud Oaks Stock Farm after her marriage to James Proud in 1894. James and Anna built a home on the site in 1905. A third home, a Dutch Colonial built in 1930, still stands at 30133 Chicago Trail. (Courtesy of Fred K. Paine.)

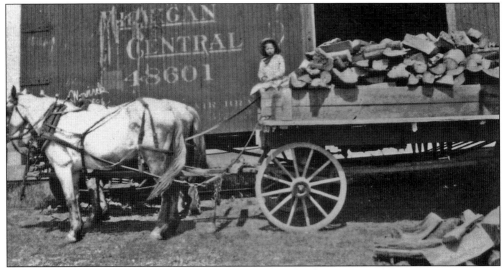

Beulah (Proud) Paine, 10, holds a team by Warwick Station around 1919 as wood is loaded for sale. Beulah Proud taught in New Carlisle from 1930 to 1934 and married Karl A. Paine in 1934. Warwick, located on the Chicago-Detroit Road at the intersection of the South Bend and St. Joseph branch of the Michigan Central Railroad, was one of several villages that once dotted Olive Township. Other towns included Plainfield, which was located east of New Carlisle at the intersection of the Michigan Road (U.S. 20) and Walnut Road; New Palestine, located east of Plainfield; and Richardson, which developed south of New Palestine. (Photograph by Theodore Proud, courtesy of Fred K. Paine.)

Two

THE LITTLE TOWN
ON THE HILL

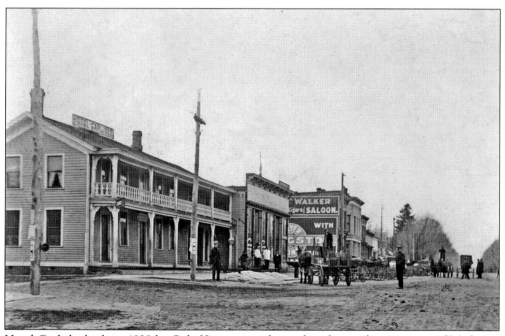

Hotel Carlisle, built in 1838 by Cole Kramer, was located at the southwest corner of Michigan and Arch Streets. Kramer sold the hotel to Capt. Richard Cramner, who operated it for several years until selling it to Joseph Ivins. The hotel contained a dining room, saloon, barbershop, and gambling room and served as a stagecoach stop along the Michigan Road. The hotel burned down in 1913. (HNC.)

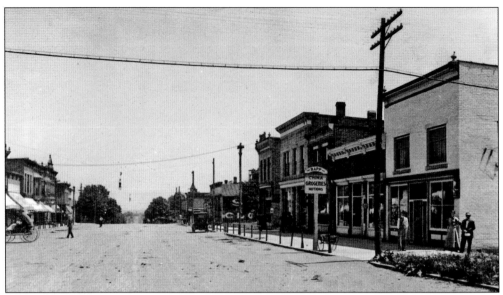

One of the most important factors in the development of the little town on the hill was its location on and near major transportation routes: the Michigan Road and the Chicago-Detroit Road. The most significant impact would come on January 1, 1852, with the arrival of the railroad. The railroad was important to the growth and success of New Carlisle and is evident in the many new buildings that were constructed after its arrival. The little town grew and prospered, and many businesses were established in town to support the growing population. The postcard above is a view of downtown New Carlisle in the early 1900s. The view is looking east to the Terre Coupee prairie. The postcard below shows the north side of Michigan Street looking west. In the foreground is F. D. Warner's Drug Store, built in 1874. (Both HNC.)

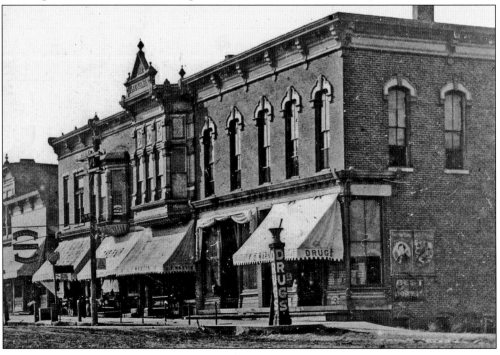

The lumber business was very profitable in New Carlisle. In this photograph, logs are being taken with horse and wagon to the sawmill near the railroad tracks. The first known sawmill was the Ewers Mill. It was purchased by Oren Tippy and Samuel Miller in 1880. Other businesses that profited from the area's lumber included the manufacturing of wagons and carriages, oaken pork barrels, furniture, and cabinets. (Courtesy of Evelyn Lewis.)

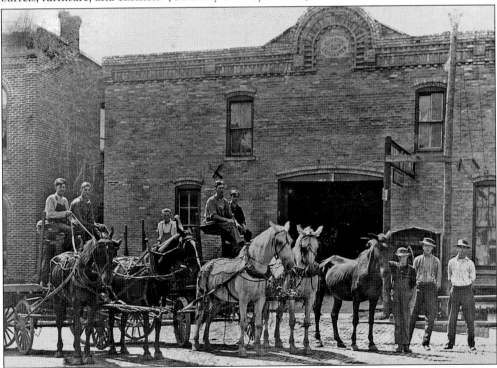

The livery stable was located on the southeast corner of Michigan and Arch Streets. The livery was one of the most important businesses before the advent of the automobile. The livery provided a place for people to keep their horses and wagons overnight. Townspeople who did not have their own carriage barns could pay to keep their horses in the stable. (HNC.)

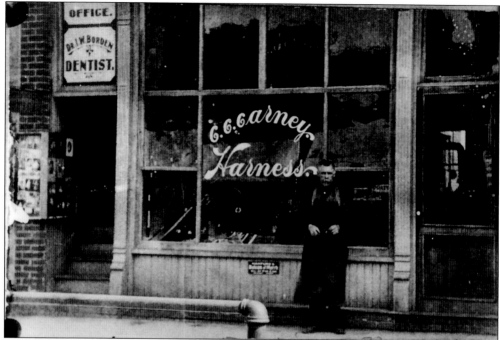

Charlie Carney is pictured around 1915 in front of his harness shop on the south side of Michigan Street. The first harness shop was opened in 1856 by Hiram Barrett. After Barrett closed his shop, Samuel Lancaster partnered with William Wair and eventually bought out Wair's interest. Lancaster eventually sold his shop to Charles Carney. Dr. Isaac Borden's dentistry office was located on the second floor. (HNC.)

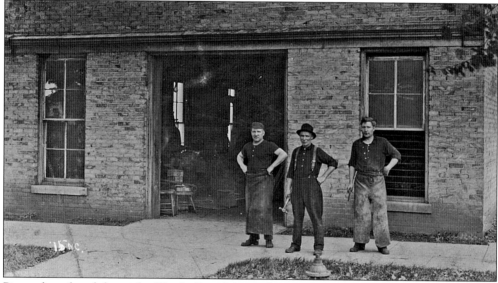

Pictured are, from left to right, Charles Baer, John Ordung, and John Cunningham standing outside of the blacksmith shop once located at 106 S. Filbert St., owned by John Ordung. Blacksmith shops flourished in the early days, and most shops employed a woodworker to make wagons, hayracks, and bobsleds. The last blacksmith shop in New Carlisle was sold in 1955 by James Perry to William Martensen, who named it the New Carlisle Iron Company. (HNC.)

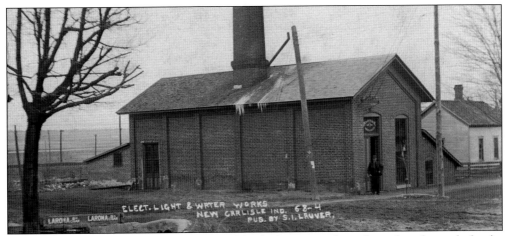

A petition was signed and presented to the board of trustees asking that a loan be made for the construction of a waterworks system for the town. Bids were received, and a new waterworks building was constructed in 1879. A dynamo was installed in the pump house for the purpose of manufacturing electricity for the town. The water and electric system was operated for many years by Elias Ackley. (Courtesy of Paula Romig.)

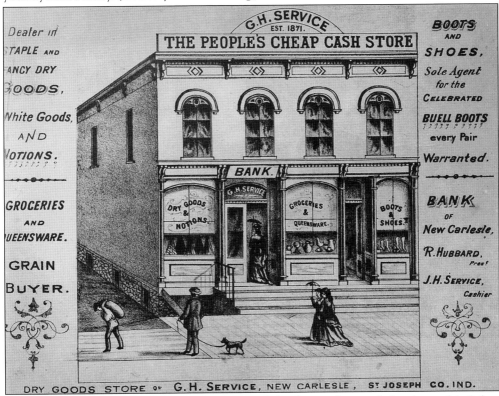

In 1867, George Service assumed management of the dry goods store belonging to his father, Jeremiah. The two-story frame structure was located on the south side of Michigan Street and featured dry goods, groceries, shoes, and boots. Jeremiah and George also established a private bank in the store with Ransom Hubbard serving as its president. The store burned down in 1898, and the First National Bank was constructed on its site in 1900. (HNC.)

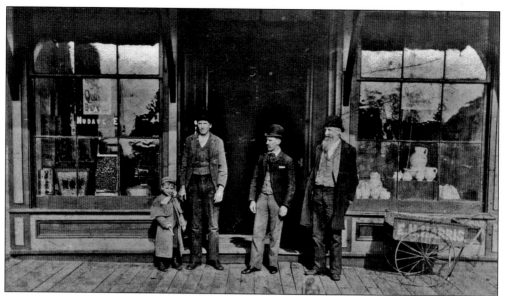

Pictured in front of Edward Harris's grocery store are, from left to right, Jerry Service, Nathanial Wade, Edward Harris, and Dr. McDonald. Edward Harris came to New Carlisle at the age of 13 and went to work as a clerk in the Van Aitken grocery store. The store was later sold to E. C. Taylor, and Harris remained with him until 1875, when he went into business for himself. (HNC.)

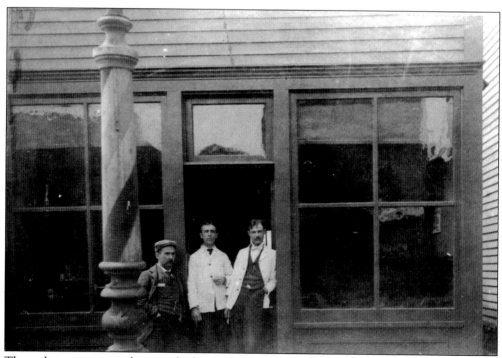

These three men were photographed outside a barbershop believed to be located on the south side of Michigan Street. The man in the middle is Joseph Wade, a barber. The other two are unidentified. (HNC.)

Newspaper advertisements for two of the local merchants in New Carlisle advertise dry goods and groceries. The ad for Service and Trowbridge Dry Goods features boots, shoes, hats, and clothing, while the ad for E. C. Taylor's Grocery Store features groceries as well as crockery, glassware, schoolbooks, and stationery. Notice that Service and Trowbridge showed its goods "free of charge." (HNC.)

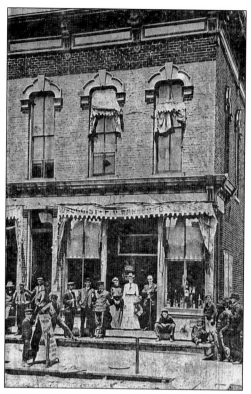

Jacob Warner opened the first drugstore in 1853. In 1874, Warner's son, Francis, purchased the business and constructed a two-story brick building at the northwest corner of Michigan and Arch Streets. The first floor contained his drugstore on the east side and T. J. Garoutte's dry goods store on the west. The second floor was a meeting room for the Terre Coupee Masonic Lodge. (Courtesy of Paul Wogatzke.)

Standing outside the Davidson and Porter Dry Goods store are, from left to right, Wes Culveyhouse, Ray DeLotter, George Doughty, Charles Trowbridge, Oscar Smith, and John Livelsberger. This photograph is featured on the cover of the book. (HNC.)

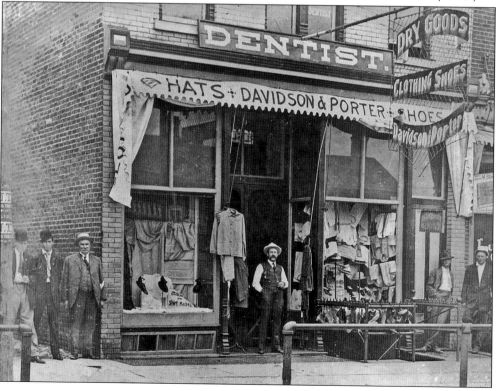

A few years prior to 1889, William Brummitt and his son, Mark, established the Brummitt Mercantile Company (right, below). When William retired from the hardware business around 1890, Mark and his brother, Arthur Sr., went into business together and renamed the company the Brummitt Hardware Company. The family lived above the hardware store, and a safe was kept on the first floor. As a precaution against robberies, a hole was cut in the floor of their apartment above the safe and a double-barreled shotgun loaded with buckshot was concealed in the opening. In 1912, Mark Brummitt sold the hardware to Fred and Ella Zeck. William Hass and Associates purchased the business in 1924, putting Joseph Ekstrom in charge of the store and lumberyard. The business at that time became known as the New Carlisle Lumber and Coal Company. (Both HNC.)

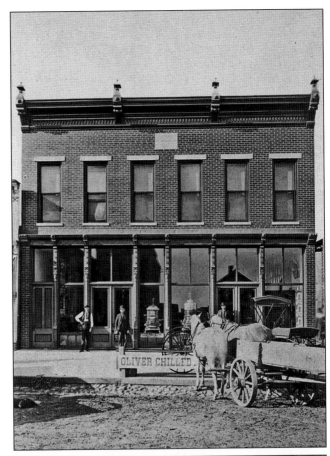

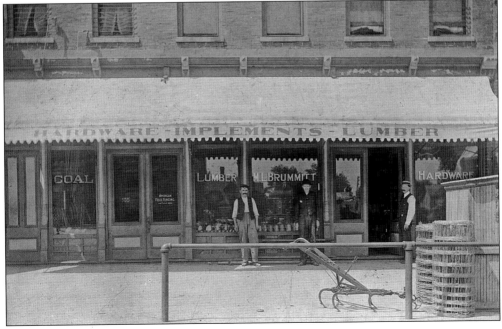

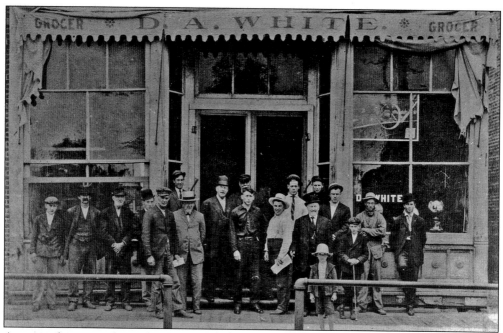

A group of men stand outside of D. A. White's grocery store around 1912. Pictured are, from left to right, Ray Delotter, Edward Swank, Mervin Crouch, Frank White, Edward Wade, ? Brummitt, Loren Brummitt, Pete Pauline, Charles White, Lute Bruch, John White, Dan White, John Hauser Sr., Glenn Wade, George Van Dusen, Dennis Culveyhouse, J. Riddle, and two unidentified. Dan White was in the grocery business for 35 years. (HNC.)

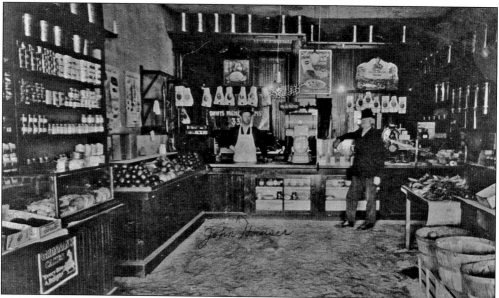

John Hauser is shown behind the counter at Hauser's Meat Market around 1918. Hauser's was located on the north side of Michigan Street. John's sister, Mildred, cut the meat in the market for a number of years. John had three sisters: Eva Sharp, Mildred Jettner, and Magdalene Madden. John married Ruth Bate, and their children were Genevieve Charlesworth, Ann Adele Eberhart, Charles, and John (Jack). (HNC.)

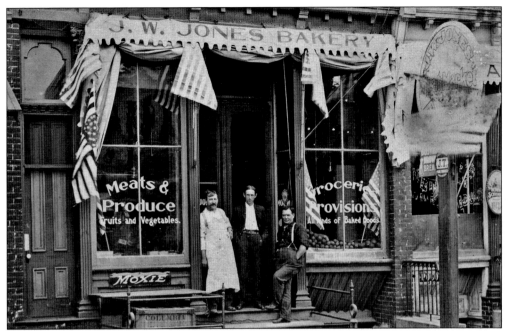

The J. W. Jones Grocery Store was located at 113 East Michigan Street. The owner, John W. Jones, went by his middle name, Will. This postcard was enclosed in a letter dated 1906 that was sent to his future wife, Mamie Lewis, who lived in Chicago. Will is identified as the man in the middle. The others are unidentified. The grocery store featured a meat market, produce, and baked goods. (Courtesy of Debbie Gliva.)

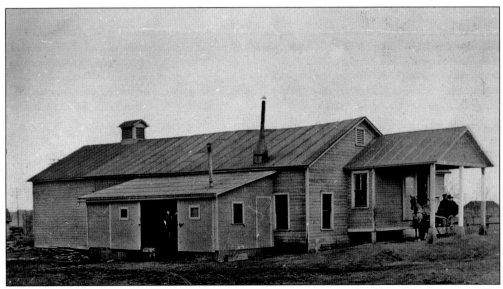

The New Carlisle Creamery was located on the southwest corner of Ada and Race Streets. The photograph was taken prior to 1900. A creamery was an establishment where milk, butter, cream, and cheese were produced and/or sold. (HNC.)

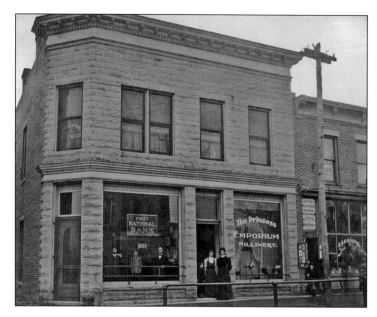

The First National Bank was built in 1900 and opened on January 2, 1901. Before then, the bank was known as the Bank of the Brummitt Mercantile Company and was located in the Brummitt's hardware store. The neo-classical building features decorative limestone and an ornate cornice. (HNC.)

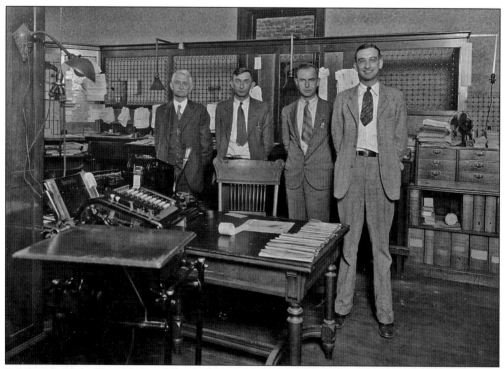

Employees of the First National Bank shown in this *c.* 1930 photograph are, from left to right, Arthur Brummitt Sr., Arthur Brummitt Jr., Ben Bates, and William Brummitt. After receiving a bank charter in 1900, Arthur Brummitt Sr. moved the banking business from the hardware store to a new building. The Brummitt family operated the bank for nearly three-quarters of a century until it was acquired by the National Bank and Trust Company of South Bend in 1963. (HNC.)

The H. C. Amen Funeral Home began in 1925. Homer and Maleta Amen purchased the William Brummitt home on the southwest corner of Filbert and Chestnut Streets and remodeled the home for their funeral business. Around 1950, their son Robert joined the business, and it became known as H. C. Amen and Son. The funeral home remains in business today at the same location; it is now operated as Kaniewski and Sons. (HNC.)

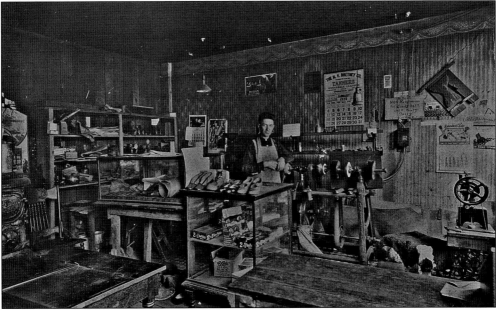

John Macias is shown working in his harness and shoe repair shop in 1925. His shop was located in the basement of Warner's Drug Store on the northwest corner of Michigan and Arch Streets. John was a very generous man and was known to give new pairs of shoes to children who could not afford them. (Courtesy of Gene and Joy VanLue.)

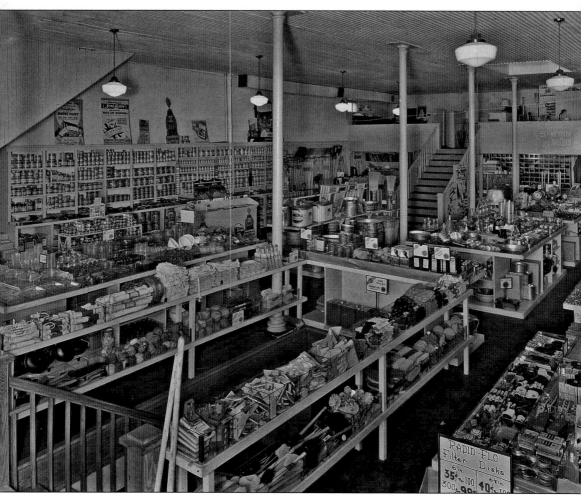

The New Carlisle Lumber and Coal Company was established in 1924 when William Haas purchased the hardware business from Fred and Ella Zeck. Haas put his brother-in-law, Joseph Ekstrom, in charge of the store and lumberyard. Following Ekstrom was Lon Moore, who managed the store for five years and built speculative homes on the north side of U.S. 20 east of town. In the 1950s, under manager Edward Penick, the New Carlisle Lumber and Coal Company branched out by platting new additions to the town, such as Vogler and Sunny Crest. This photograph of the interior of the store was taken around 1927, when Joseph Ekstrom was the manager. A set of stairs led to the second-floor office balcony. Over 120 years later, the building continues to serve as a hardware store; it is currently owned and operated by Jack and Hazel Houston. (HNC.)

This c. 1930–1935 photograph shows customers at the meat counter at the A&P store. The Atlantic and Pacific Tea Company was a grocery chain started in 1859. The store was located on the north side of Michigan Street in downtown New Carlisle. Walter Graves is behind the counter on the right. Graves later became manager of another A&P store in Michigan City. (Courtesy of Norbert Graves.)

Roy Palmer (left) and Betty Roloff (right) stand behind the counter at the Soda Bar located at 133 East Michigan St. The Soda Bar was a popular hangout mostly for teenagers. Both lunch and after-school hours were particularly busy with the school crowd. One-dip ice cream cones, candy bars, and Coca-Cola drinks all sold for a nickel apiece. The jukebox also took a nickel to play the favorite tune of the day. (Courtesy of Judy Brown.)

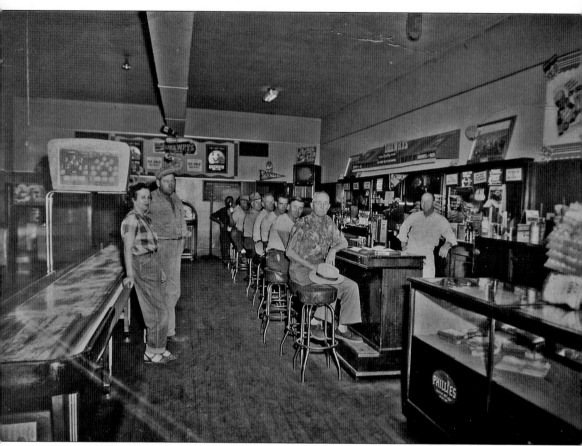

Established in 1946 by Harold and Betty Roesner, the Red Inn was located on the south side of Michigan Street. The Red Inn was sold in 1985. This *c.* 1952 view shows the interior of the bar. Harold Roesner is shown behind the bar serving customers Ed Hosty, Goff Stevens, Fred Leer, Louis Chizar, Wally Reed, Dutch Propst, and John Tarr. (Courtesy of Debbie Colanese.)

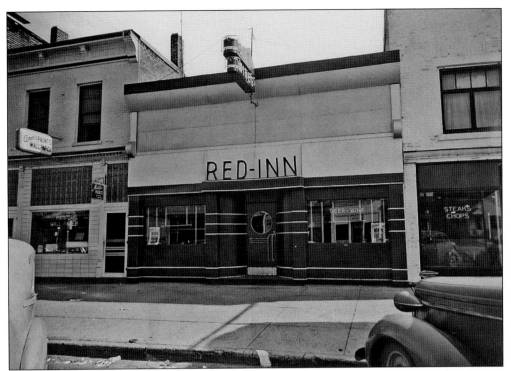

The photograph above shows the art deco exterior of the Red Inn. Owners Harold and Betty Roesner moved the business across the street in 1962. The building was then remodeled and became a part of the Home Café. Located in the building to the east was Amen's Paint and Wallpaper store. (Courtesy of Debbie Colanese.)

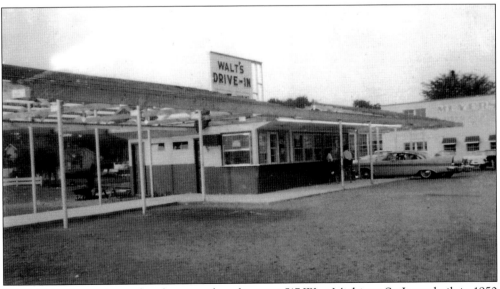

Walt's Drive-In was located at the west edge of town at 517 West Michigan St. It was built in 1950 as the B&K Drive-In. Walter Graves bought the building in 1958 and operated it until 1968. An ad appearing in the *New Carlisle News* in 1959 advertised, among other things, Spanish dogs and frosted malts. (Courtesy of Norbert Graves.)

Employees are pictured outside of the Welcraft Corporation building in the 1950s. The company was started in North Liberty in 1951 and moved to New Carlisle in 1953. It was located on the site of the old opera house on the north side of Michigan Street. The company was in the business of gasket cutting and then the manufacture of wire assemblies for refrigerators and other appliances. The company was later renamed Easy Heat and moved east of town. (HNC.)

Three

GOING PLACES

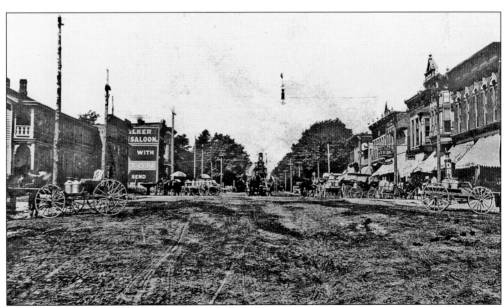

An early view of the Michigan Road (Michigan Street) is shown before paving. The Michigan Road was one of the most important transportation routes, opening up the state to settlement. The road connected Madison on the Ohio River to Michigan City on Lake Michigan. The road was to be a direct route, but had to be resurveyed around the Kankakee marshes to South Bend and west through New Carlisle. (HNC.)

Men are shown working on the railroad tracks in front of the Lyman Egbert residence. The first train came through New Carlisle on January 1, 1852. With the arrival of the railroad, the town of New Carlisle continued to grow and prosper while other towns such as Hamilton declined and virtually disappeared. (HNC.)

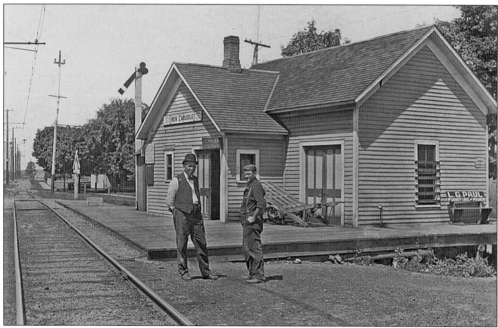

John Ayers and William Miller stand outside the New Carlisle train depot. The men worked as ticket agents for the South Shore and Northern Indiana Railway. The depot, once located along the South Shore tracks on Zigler Street, served passengers from both the South Shore and the Northern Indiana Interurban trains. (Courtesy of Paula Romig.)

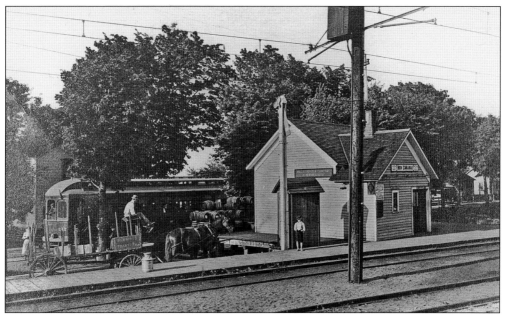

A Northern Indiana Interurban train is shown behind the depot on Zigler Street. In 1907, two electric lines were completed. One of the lines went from South Bend to Chicago and the other from South Bend to Michigan City. The depot served as the station for the Interurban passengers. (HNC.)

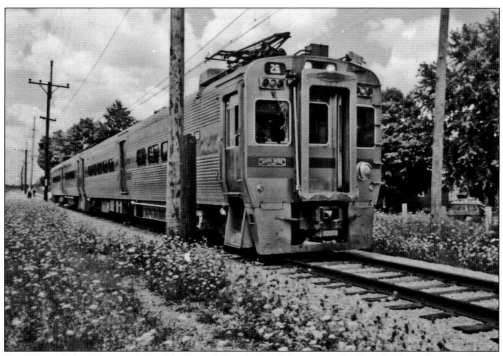

First named the Chicago Lake Shore and South Bend Railway, The South Shore began offering service on June 30, 1908, between South Bend and Michigan City. Soon after, it was continued on to Chicago. A passenger stop was located at the bottom of Arch Street for many years. (Courtesy of the Northern Indiana Center for History.)

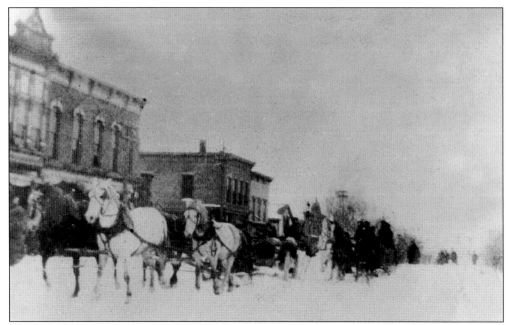

The Great Automobile Race in 1908 from New York to Paris was the longest automobile race in history. Sponsored by the *New York Times* and *LaMatin*, a Paris newspaper, the race featured teams from the United States, France, Italy, and Germany. The Thomas Flyer, the U.S. automobile, was declared the winner. The drivers encountered severe winter weather along the way, as seen in this photograph in downtown New Carlisle. (HNC.)

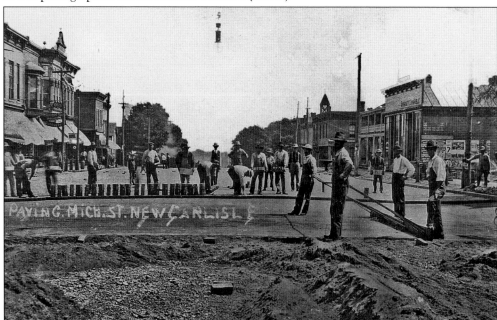

In 1908, paving bricks were installed in New Carlisle. The "paving gang," as the men were referred to, are shown laying bricks along Michigan Street in the downtown business district. They laid the bricks by hand from Arch Street west to Meridian Street. Paving would greatly improve travel along the road. (HNC.)

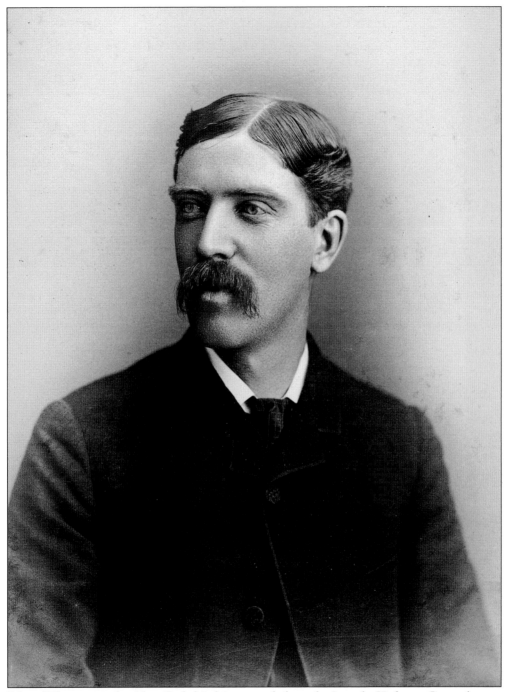

Edward Harris served as New Carlisle's first counsel along the Lincoln Highway. Counsels were appointed in each community by the Lincoln Highway Association to promote the highway and to communicate with and report to the Lincoln Highway Association regarding the road. After Harris's death, James Proud became the local counsel. (Courtesy of the LHA Collection/ University of Michigan.)

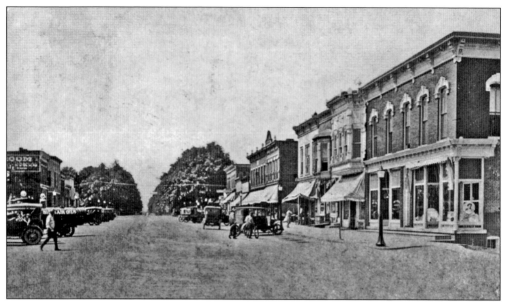

This picture postcard shows the Lincoln Highway through downtown New Carlisle. The Lincoln Highway was first conceived by automobile enthusiast Carl Fisher. In 1912, Fisher and business associate James Allison invited automobile leaders to a dinner in Indianapolis, where he announced his idea of a coast-to-coast highway. The highway was named to memorialize Abraham Lincoln. New Carlisle was selected to be on the original 1913 route. (HNC.)

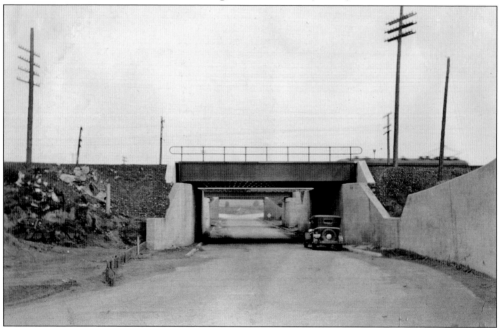

The famed "Death Crossing" along Lincoln Highway was eliminated when the viaduct was built in 1925. The tracks of the New York Central Railroad, the Northern Indiana Railroad, and the Chicago South Shore and South Bend Railroad utilized several sets of tracks that had to be crossed by motorists. Several deaths occurred due to the dangerous crossing. (Courtesy of LHA Collection/University of Michigan.)

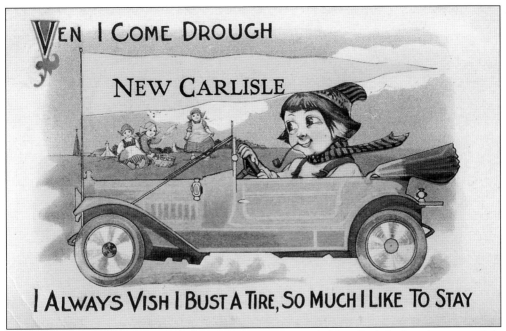

This postcard was one of many produced to promote not only New Carlisle, but the automobile as well. The 1915 postmark coincides with the year the Lincoln Highway was dedicated in Indiana. (HNC.)

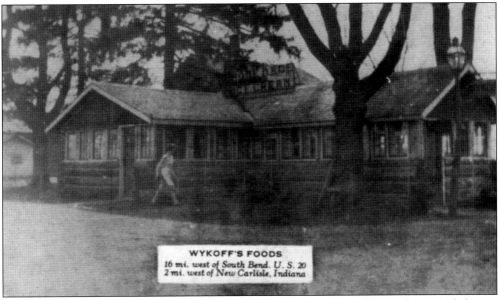

The Wykoff Log Cabin Restaurant was a popular highway spot, located west of New Carlisle on a family farm. Howard Wykoff owned Holstein cows and delivered milk. He built a small log cabin structure where his wife, Rose, sold her famous homemade ice cream, made in 10-gallon lots in the well pump house, for 5¢ a cone. Anticipating increased traffic along the highway for the 1932 World's Fair in Chicago, Howard and his sons moved the building to front the road, enlarged and expanded to offer a restaurant menu, and installed gas pumps just east of the restaurant. (Courtesy of Paula Romig.)

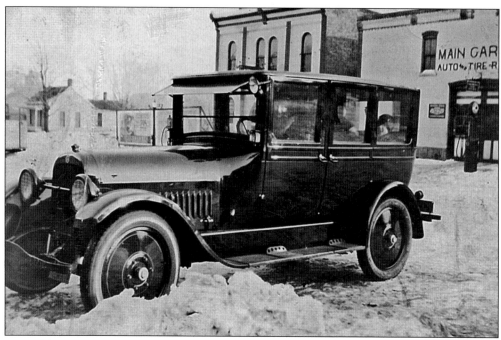

A Studebaker car is parked on the north side of Michigan Street in downtown New Carlisle, January 1926. Across the street is the Main Garage advertising auto and tire repair. With the advent of the automobile, gas stations and garages replaced the old livery stable and blacksmith shops. Better roads were needed and the "Good Roads" movement was making traveling by automobile safer and easier. (HNC.)

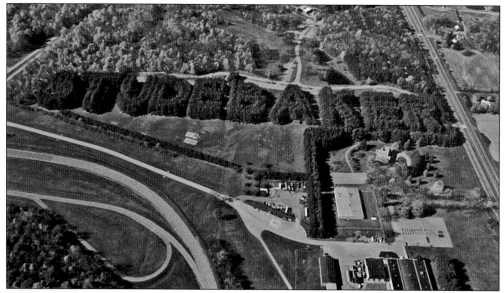

The Studebaker tree sign was listed in the *Guinness Book of World Records* in 1987 as the "largest living" advertisement sign. In 1938, the Civilian Conservation Corps (CCC) planted 8,259 six-inch seedlings extending over a half mile. The tree sign served as a salute to a growing aviation industry in the area. Each of the "letters" is composed of two rows of white pines forming the border around three rows of red pines. (Courtesy of St. Joseph County Parks.)

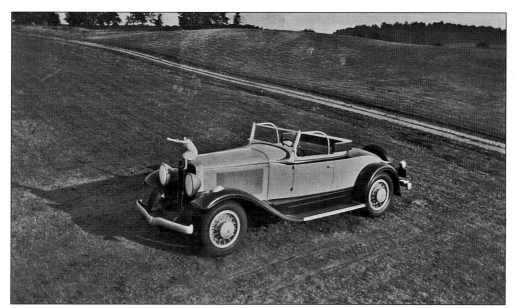

Ruth (Hensell) Meyers poses as the hood ornament on this giant 1931 Studebaker. The Studebaker Clubhouse and Proving Grounds were built in 1926 near New Carlisle. In 1931, the Studebaker Corporation built the largest car in the world and parked it at the entrance of the proving grounds on State Road 2. The car must have been quite a sight and made a great photo opportunity for many. (Courtesy of Carl Meyers.)

Ernie and Ruth Meyers opened Meyers Chevrolet in 1950. The new car dealership was built on the northwest corner of Michigan and Meridian Streets. The new building featured a new-car showroom. The dealership offered a gas station, towing service, and automobile repair. Later, the dealership sold boats as well. (Courtesy of Gladys (Meyers) Morse.)

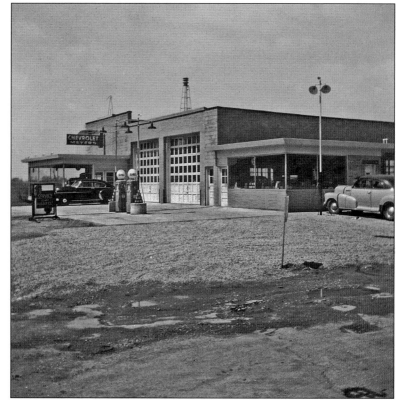

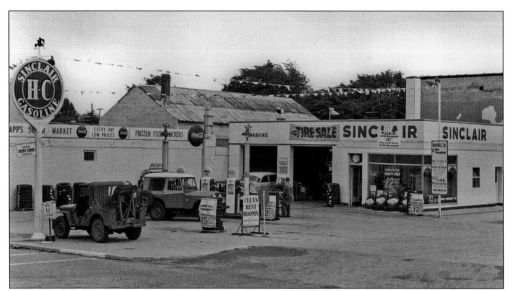

Don Tolmen is pictured pumping gas for a customer at Bisel's Sinclair gas station. The gas station was located on the southeast corner of Michigan and Arch Streets. Harold Bisel purchased the station from Chuck Runnels in 1957 or 1958. He operated the gas station for 18 years; during that time, Sinclair was sold to Arco. (Courtesy of Don and Wanda Tolmen.)

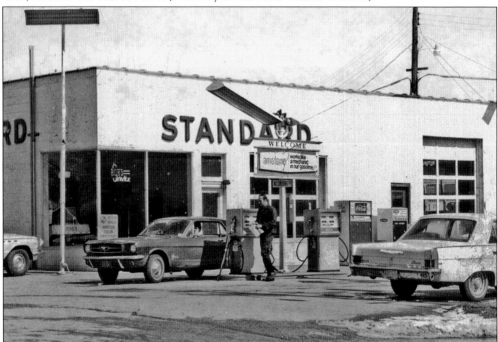

Bob Garoutte started Bob's Service in the early 1960s on the northeast corner of Filbert and Michigan Streets. At one time, there were four gas stations in town: Simmermeyers, Bisel's Sinclair, Garoutte's DX, and Prestin's Standard. The four owners met once a month and traded parts, and agreed with Bob's suggestion that only one station stay open on Sundays. The other stations put signs in their windows to notify customers which station was open that day. (Courtesy of Denise Garoutte.)

Four

DOWN ON THE FARM

Melvin Melady is driving his team of horses to the field to cultivate corn in 1930. The picture was taken in front of the Melady home once located at 31189 East U.S. 20. Farming and agriculture have always been the backbone of the New Carlisle community. Early settlers saw the great potential of the flat, fertile fields and the rich black soil in which to plant their crops. (Courtesy of Sadie Melady.)

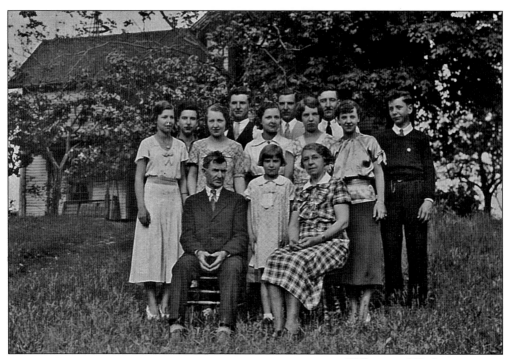

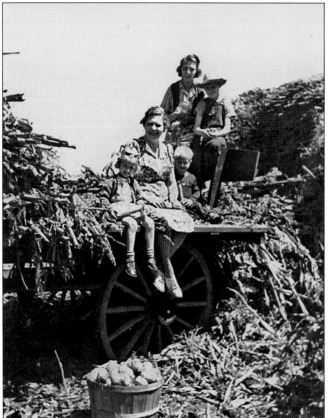

William and Katherine Hooton raised their 11 children in the home that William grew up in, located at 56250 Timothy Rd. Pictured in front of their farmhouse are, from left to right, (first row) William, Ginny, and Katherine; (second row) Polly, Katherine, Ruth, Dorothy, and Helen; (third row) Fay, Bob, Warren, John, and Don. (Courtesy of Myles and Beverly Hooton.)

Sitting on a wagon during harvest time at the Hooton farm are, from left to right, Norma Hooton, Aunt Verna Venzke (Mildred Hooton's sister), Myles Hooton, Mildred Hooton, and Norris Hooton. The picture was taken in 1941. The family raised cows and pigs and grew wheat, beans, and corn. (Courtesy of Myles and Beverly Hooton.)

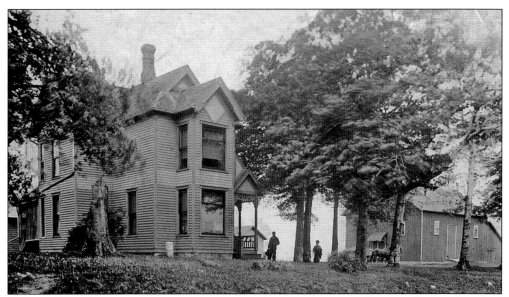

The Rodgers farm is located south of New Carlisle on Timothy Road. The house was built by James and Ida Rodgers. Their son Virgil Rodgers, shown with the horse and buggy below, was born on the farm where he spent his life. He married Ada Carr on August 23, 1905. They had one son, Carr Rodgers, and four daughters, Martha (Rodgers) Holaday, Mary Alice (Rodgers) Horvath, Adah Ruth (Rodgers) Weaver, and Vivian (Rodgers) Purvis. The family raised pigs and chickens and milked two cows by hand. They also grew corn and wheat and tapped trees for maple syrup in the spring. Besides farming, Virgil served as the Olive Township Trustee for eight years. The Rodgers farm remains in the family 130 years later as Virgil's grandson, Jim Rodgers, and his wife, Toby, maintain the farm. (Both courtesy of Mary Alice Horvath.)

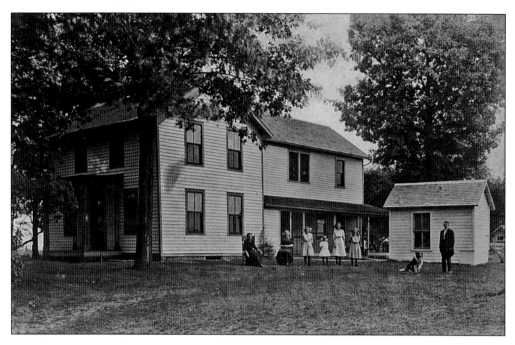

The 1870 Thomas Jefferson Garoutte farm is located at 54544 South Timothy Road. The original acreage of the farm was 120 acres up to the marsh. Coming from Ohio with his parents in 1830, the home's builder, T. J. Garoutte (1823–1899) was one of the first dozen settlers in Olive Township. He became a successful farmer and businessman and owned considerable property in the area. T. J. married Sarah Burk in 1850, and they had eight children. He was elected one of the first trustees of the Carlisle Collegiate Institute in 1860 and was the second Olive Township trustee from 1871 to 1877. Pictured in front of the farmhouse are, from left to right, Martha, Clara, Olive, Beatrice, Ella, Ollie, and Bradley Garoutte. (Both courtesy of Paula Romig.)

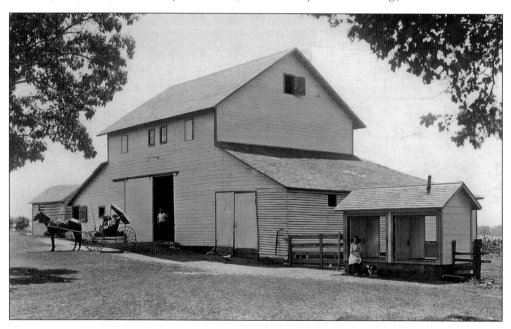

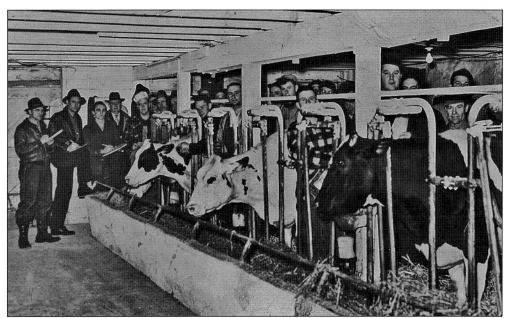

A. T. Marvel came to New Carlisle in 1943 as a vocational agriculture teacher. At the time, area farmers were producing low crop yields, as the soil was run-down and deficient of nutrients. He noticed that the techniques of the New Carlisle farmers were seriously out of date. In 1946, he started the Farmer's Adult Evening Classes to instruct farmers on revolutionary technology and the latest methods of raising crops. His methods and practices proved very successful to the farmers who attended his classes. The above photograph shows the farmers inside Ernie Meyers's barn during one of the evening classes. The photograph below shows the 1956 Farmer's Achievement Banquet sponsored by the Farmer's Evening School. The banquet recognized farmers with diplomas for their attendance at the classes and trophies for various achievements, such as top yields, best balanced farming, and farmer of the year. (Both courtesy of Elsie Cooreman.)

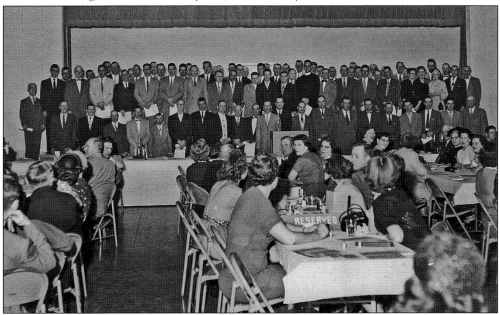

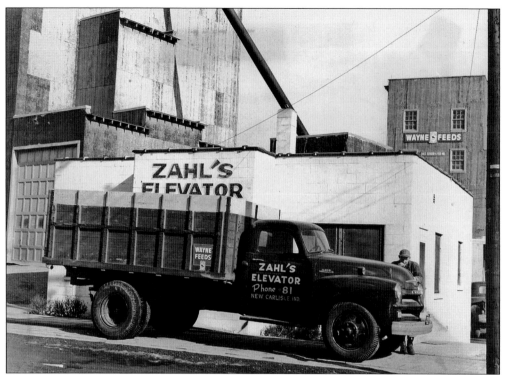

Zahl's Elevator began in 1933 when Carl Zahl Sr. and his wife, Alma, purchased a flour mill on Arch Street. By 1949, Zahl's began to sell feed, as the flour business had declined. That same year, a new 20,000-bushel-capacity elevator was built at the northeast corner of Michigan and Race Streets. In 1952, a modern feed mill was constructed. Zahl's Elevator continues today under the operation of the Millar family. (Courtesy of Gladys Morse.)

Paul Cooreman was one of the many farmers who attended the Rapid Soil Improvement classes taught by A. T. Marvel, and who successfully improved his annual crop yields. In 1956, Cooreman set a new county record by producing an average of 175 bushels in the 5-acre corn contest. (Photograph by Dick Deer, courtesy of Elsie Cooreman.)

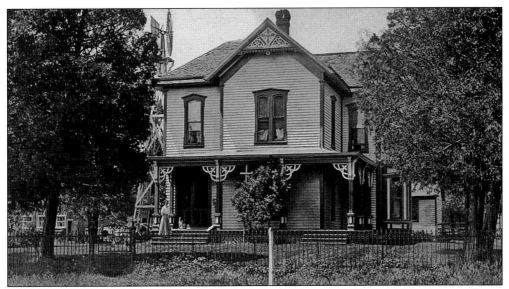

In 1931, Alex Horvath moved his wife, Elizabeth, and sons, Steve, John, and Alex Jr., from South Bend to a farm in New Carlisle. The farmhouse had been built in 1872 by William F. Brown. The Depression prompted Alex to supplement his income from the Studebaker Company by purchasing a farm and growing his own food. The family also raised dairy cows, producing Grade A milk that was sold to local dairies. When a fire destroyed their barns in 1953, Steve and John were determined to rebuild a modern, fireproof barn. A new state-of-the-art, 50-cow barn was built of concrete block. Along with the barn, John and Steve devised and constructed a silo-type hay keeper that greatly improved the storage of hay. Alex's grandsons, Allen, Rich, and Tom, continued the farming tradition until they retired in 2000. (Both courtesy of the Horvath family.)

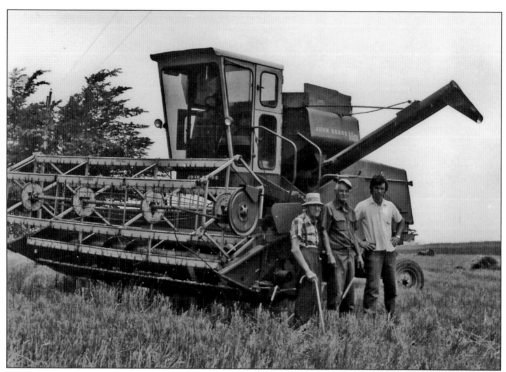

The Wykoff farm is located about a mile west of New Carlisle on U.S. 20. Edwin and Annie Laurie Wykoff bought the farmhouse that was originally owned by the Asa Warren family. After Edwin's death, Annie Laurie moved to town with her two daughters, Inez and Mary Ellen. Her son, Howard, and his wife, Rose, lived in the farmhouse and took over operation of the farm. When Howard and Rose moved to Florida in 1942, their son, Dick, bought the farm. Dick operated the farm until 1974 when he sold it and the house to son Dan. The farm is now under operation by Dan's son, Jason, a fifth-generation Wykoff. The photograph above shows, from left to right, Howard, Dick, and Dan Wykoff in front of a combine. The photograph below shows Dick with son Dan driving a tractor pulling a wheat swather. (Both courtesy of Sandy Wykoff.)

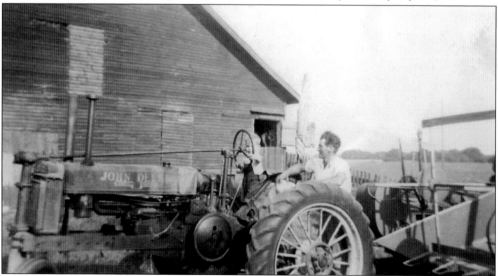

Five

PEOPLE AND PLACES

Richard Risley Carlisle was born in 1814 to Capt. John and Achsah (Allen) Carlisle in Burlington County, New Jersey. Richard married Rebecca Willetts on October 15, 1833. They had two sons: John born in 1834–1835 in New Jersey and Henry born in 1837–1838 in St. Joseph County. Carlisle traveled to Olive Township with his family in 1835, purchased 160 acres from Lazarus Bourissa, and platted the town of New Carlisle. (Courtesy of John Kovach.)

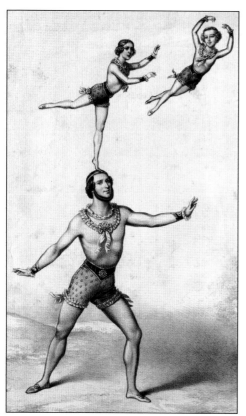

Carlisle became a circus and theatrical performer with his first noted performance in 1841. Carlisle developed his trademark child juggling routine in 1840–1841, an act that would eventually be known in the circus world as the "Risley" act. Carlisle took Risley as his professional name and was often called "Professor Risley." (Courtesy of John Kovach.)

In 1864, Carlisle brought the first U.S. circus performers to Yokohama, Japan, and while there, he built and opened the first ice cream saloon in Yokohama in March 1865. In 1867, Carlisle brought the first group of Japanese acrobats/performers to the United States and to Paris in 1869. Carlisle died on May 25, 1874, in Philadelphia at the age of 60. (Courtesy of John Kovach.)

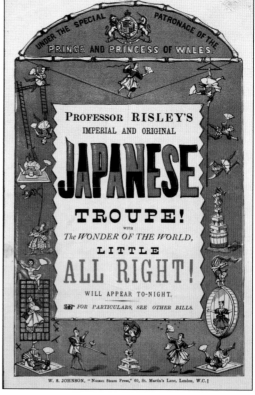

Schuyler Colfax, born in New York on March 23, 1823, moved to New Carlisle with his mother and stepfather, George Matthews, in 1836. They built their first home on the southeast corner of Michigan and Bray Streets, and Matthews opened a store where Colfax worked as a clerk. The family moved to South Bend in 1841. By the age of 20, Colfax was editor of the *South Bend Free Press*. In 1845, he bought the newspaper and published it as the *St. Joseph Valley Register*. Elected to Congress in 1854, Colfax helped form the Republican Party. Colfax served as a U.S. representative from 1855 to 1869, speaker of the house from 1863 to 1869, and as vice president of the United States from 1869 to 1873, serving with Pres. Ulysses S. Grant. (Courtesy of the Northern Indiana Center for History.)

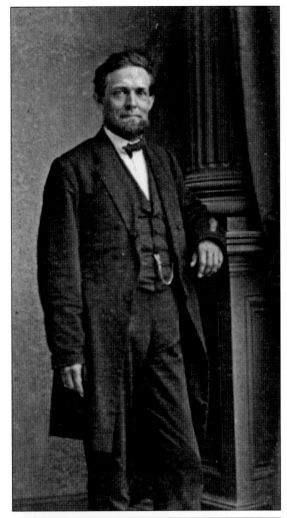

This house, once located near the northeast corner of Michigan and Filbert Streets, was one of the homes that Schuyler Colfax lived in during his stay in New Carlisle with his mother, Hannah, and stepfather, George Matthews. The Matthews family was very religious and maintained a Sunday school in their home until moving to South Bend. (HNC.)

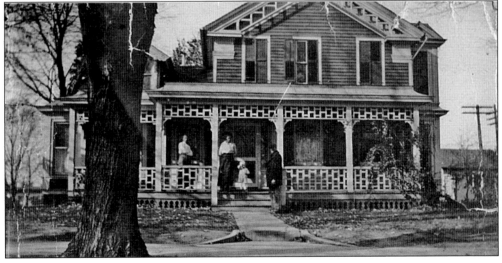

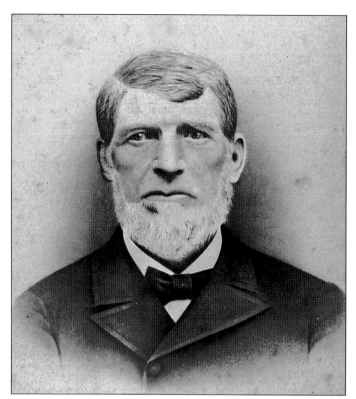

Dr. Joel Harris was New Carlisle's first permanent doctor. Born in 1811 in Rockingham, North Carolina, he graduated with honors from medical school in 1832. In 1859, he moved to New Carlisle with his wife, Charlotte Compton. Dr. Harris served as a school trustee and was a deacon in the Community Church. He died in 1887. (Courtesy of Bob Taylor.)

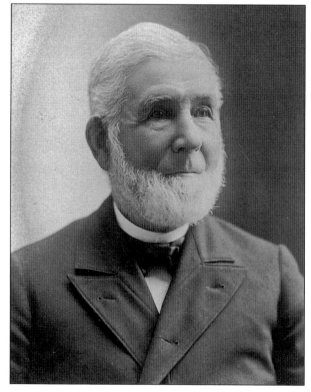

Jeremiah Service (1812–1898) traveled from New York to this area in 1837 after hearing about the good soil in northwest Indiana. He married Sarah Flanegin in 1847, and they had six children, two of whom died early in life. Jeremiah was a farmer and businessman. He owned a dry goods store that also included a bank that he operated with his son, George. He was very active politically and served one term as a state representative in 1852. He served as justice of the peace for four years and was postmaster in 1843. (HNC.)

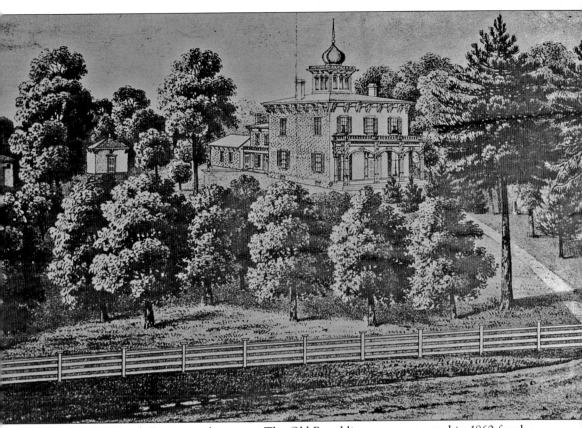

The Oak Hill Stock Farm, now known as The Old Republic, was constructed in 1860 for the Service family. The Italianate home features a central cupola topped by a Turkish onion dome. After sitting vacant for nearly 30 years, the house was purchased by Historic New Carlisle, Inc. in 1998 and rehabilitated for use as an office, local history museum, and special event facility. The second floor features inn rooms. The house is listed on the National Register of Historic Places. (HNC.)

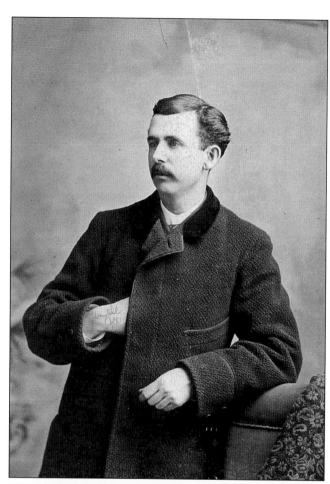

George Service was born in 1848 to Jeremiah and Sarah Service. He was brought up in the mercantile and banking business, and in 1867, he assumed management of the dry goods store established by his father. George assisted in organizing a bank inside the store. Aside from running the store, George became a very successful grain dealer. He married Mary Hews, and they had three daughters, Clara, Lizzie, and Anna. (HNC.)

George Service and his wife, Mary, built their Italianate-style home in 1875 at the southeast corner of Michigan and Cherry Streets. George sold the home in 1900. In 1919, a group of businessmen bought the home and established a sanitarium. A faith healer named Billy Mays held his practice at the sanitarium for about three years before he was run out of town. (Courtesy of Paul Wogatzke.)

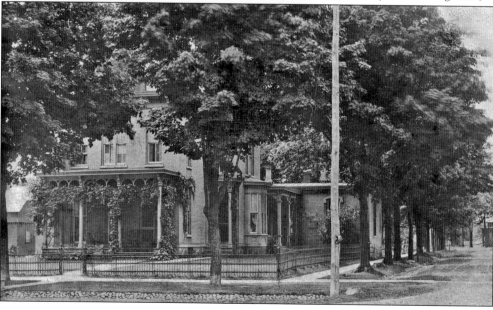

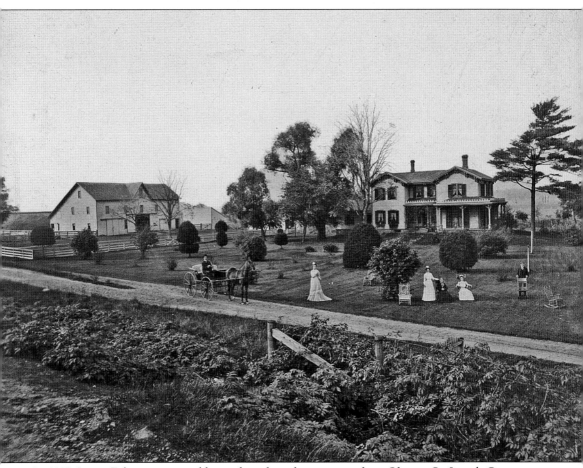

In 1837, James Egbert convinced his widowed mother to move from Ohio to St. Joseph County. James married Delilah Druliner in 1846, and a year later, they built a new two-story farmhouse. James cleared the land around the farm and raised stock. They had three children, Leroy who died in infancy, Lyman C., and Arvilla. Lyman was born in 1854 and was a successful businessman. The house, located north of the railroad tracks, originally faced south toward the tracks. At some point around 1908, changes were made to the house, and the front door was moved to face east. (Courtesy of Pat Gloss.)

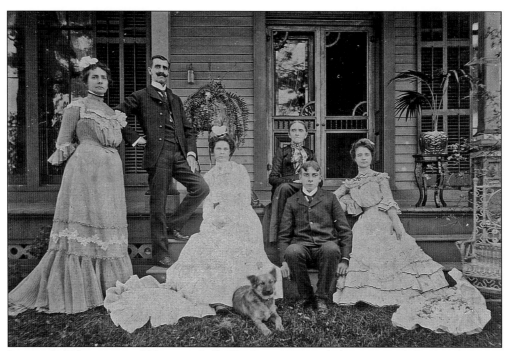

Lyman C. Egbert married Florence Belle Wade in 1877, and they retained the family home. This photograph shows the Egbert family. Pictured are, from left to right, Florence, Lyman, unidentified, Delilah (mother of Lyman), Frank (son of Florence and Lyman), and unidentified. (Courtesy of Pat Gloss.)

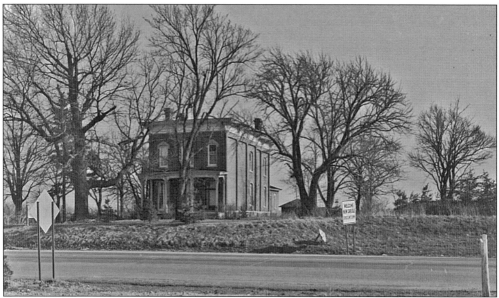

The Theodore Borden house at 910 West Michigan Street was built in the Italianate style. Construction on the two-story brick home began in 1868 and was completed in 1870. Theodore Borden was born in 1822 and moved to Indiana in 1845. He married Eliza Ann Whitlock in 1850. He was in the dry goods and grocery business for several years and served as New Carlisle's postmaster for seven years. (HNC.)

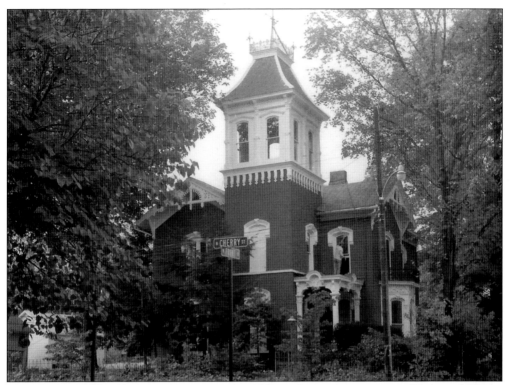

The Ransom Hubbard house was constructed in 1881 on the southwest corner of Front and Cherry Streets. The Italianate villa-style home reflected the wealth and prominence of Hubbard, as he was a successful farmer, stock-raiser, and businessman. He was involved in politics and served three terms as a county commissioner. He also helped to organize the First National Bank in South Bend in 1863. (HNC.)

A picture postcard shows the view of the south side of Chestnut Street east of Arch Street in New Carlisle. This section of town was part of Compton's first addition that was presented on July 28, 1883. The homes date back to the mid-1880s and were most likely built soon after the lots were platted. (Courtesy of Paul Wogatzke.)

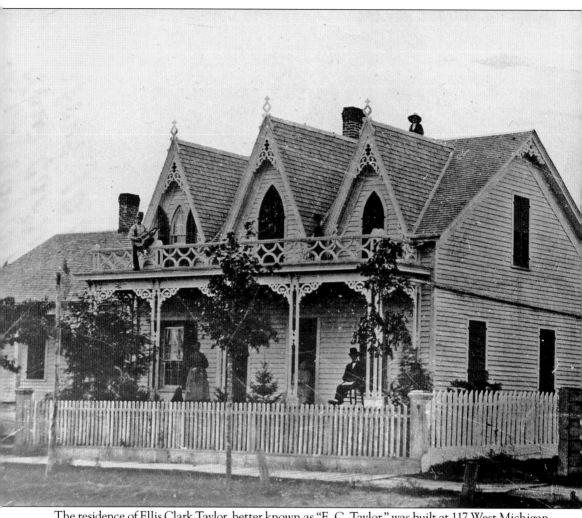

The residence of Ellis Clark Taylor, better known as "E. C. Taylor," was built at 117 West Michigan St. in the Gothic Revival style. This picture was taken around 1885. The young man on the porch roof with the guitar is his son Harris Taylor. Ellis married Sarah Harris in 1856. They came to New Carlisle in 1864. Ellis operated a grocery store for many years and served as the town treasurer for 14 years. (HNC.)

Kathleen "Kitty" Wade was born in 1894 to John and Grace Miller. After graduating from New Carlisle High School in 1912, she became a teacher. In 1925, she became the head librarian at the New Carlisle and Olive Township Public Library where she remained for 40 years. In 1956, Kitty and her friend Marguerite McCord Watt wrote and published the history of New Carlisle titled *New Carlisle—The Story of Our Town 1835–1955*. (HNC.)

In 1900, the Carlisle Clover Club, a literary and social club for young women, appointed a committee to establish a library in New Carlisle. Fundraisers were held to acquire new books, and other books were donated. The library opened on February 21, 1902. Members of the club served as librarians. In 1917, the New Carlisle Chamber of Commerce formed a library committee. Arthur Hubbard donated his property on Michigan Street, a grant was received from the Carnegie Corporation in the amount of $9,000, and the New Carlisle and Olive Township Public Library was dedicated in June 1921. (Courtesy of Mary Ann Swope.)

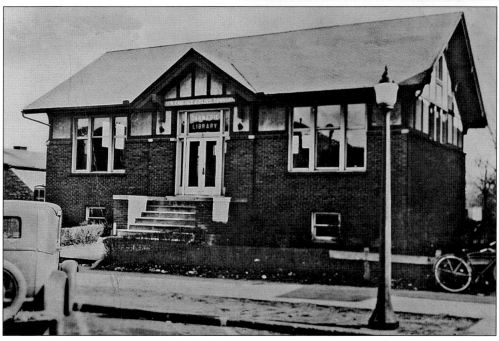

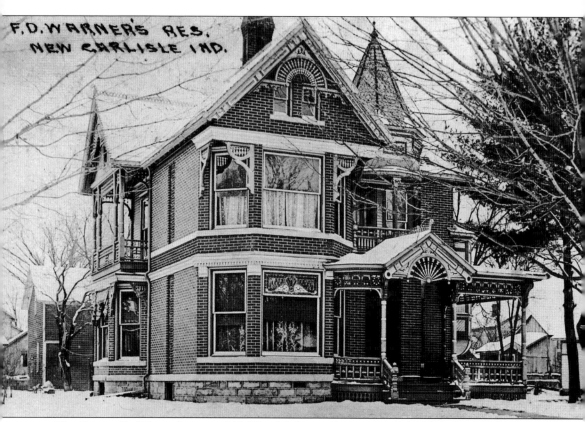

The Francis D. Warner house at 214 West Michigan St. was constructed in 1893 in the Queen Anne style. This early photograph shows the fine architectural details such as a second-story tower, front porch, and stained-glass windows. During construction, the *St. Joseph Valley Register* newspaper gave several updates as to how the construction on the Warner residence was proceeding. (Courtesy of Paul Wogatzke.)

Francis D. Warner was born in Hamilton, Indiana, on December 1, 1842. He married Audella Pratt on April 24, 1869. A pharmacist, he operated Warner's Drug Store at the northwest corner of Michigan and Arch Streets and was president of the Indiana Pharmaceutical Association. Warner served as postmaster for 20 years and held the office of town clerk. A historian, Warner recorded much of the early history of the New Carlisle area. (HNC.)

The William Brummitt residence was constructed on the southwest corner of Filbert and Chestnut Streets. Brummitt operated the Brummitt Mercantile Company with his son, Mark, and retired from the business in 1890. The two-story, Queen Anne–style home featured a two-story bay window and many decorative features. The house was purchased in 1925 by the Amen family for use as a funeral home. (HNC.)

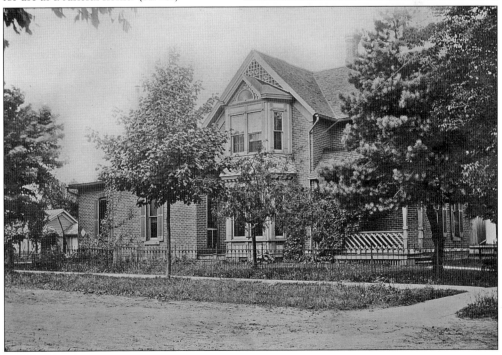

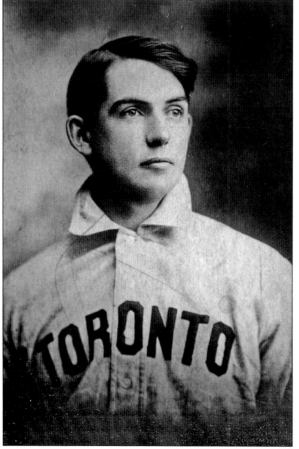

Ella Ayers is pictured with her sons, Doran (left) and Dale (right), in front of their home at the southwest corner of Front and Bray Streets. The postcard is addressed to Ella's husband, John. "Dear husband, A man came along our street taking pictures—they were so good I bought ½ doz. Wish you had been here to be in it too. We are all well going to school every day. Dale likes it fine." (Courtesy of Paula Romig.)

Elmer Moffitt was born in 1878 to Mansfield and Savannah (VanDusen) Moffitt. He attended New Carlisle High School where he was a star baseball player. He played for the South Bend Central League team in 1903 and in 1906 was sold to the Toronto team of the International League. In one game, Moffitt retired 42 consecutive batters, allowing only one single. His team won 1-0 against Syracuse. (Courtesy of Chuck and Sharon Moffitt.)

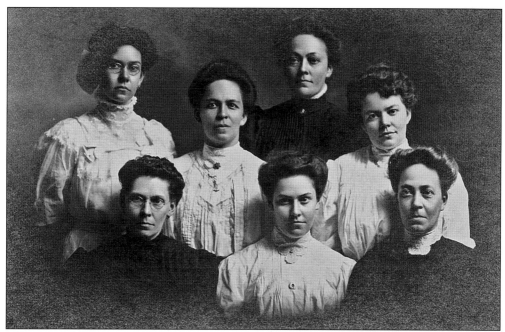

The Wenger Sisters (above) around 1910 are, from left to right, (first row) Rena, Hazel, and Lydia; (second row) Ruby, Ida, Lizzie, and Belle. The seven sisters and their four brothers were raised on a Chicago Trail farm on the Terre Coupee prairie just east of Hamilton. In 1910, they moved into a two-story home on Chestnut Street (below) on the site of the present post office. The house was preserved and moved to Elm Street in 1981. Only Rena and Hazel married. Lizzie and Lydia rarely left the house. Ida and Belle managed the Farmer's Grain Company for many years until it was purchased by Carl Zahl Sr. Belle later worked at the bank, and Ruby worked at Ray Evan's print shop on Filbert Street. The sisters also owned an icehouse located in their backyard and sold ice in the 1930s and 1940s. (HNC.)

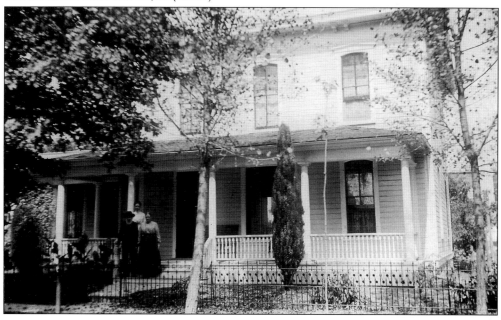

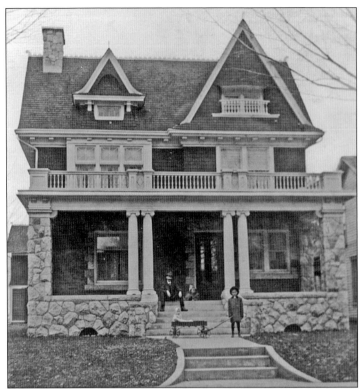

The Arthur Brummitt Sr. home was constructed in 1906 and completed in 1907. The Queen Anne–style home is located on the northeast corner of Michigan and Cherry Streets. Arthur Brummitt Sr. and his wife, Ada, had four children, Arthur Jr., Worth, Ruth, and Donald. Arthur Brummit received a bank charter in 1900 and opened the First National Bank of New Carlisle in 1901. The Brummitt family operated the bank for 62 years. (HNC.)

The Edward and Carrie (Service) Harris home located at 226 West Michigan St. was built in 1916. Edward Harris, affectionately known as "Uncle Ed," was well-known and beloved by everyone in the community. Harris, a grocer for 35 years, was very involved in the affairs of the community and was president of the board of trustees and also served as the local counsel for the Lincoln Highway Association. (Courtesy of Paula Romig.)

Dr. John Luzadder started his medical practice in New Carlisle around 1932 and continued until 1972. He used the west side of his home's main floor for his office and waiting room at 123 West Michigan St. During his practice, he routinely attended to patients in their homes and was a longtime doctor for the Haven Hubbard Home. His wife, Dorothy, assisted him as his nurse. (Courtesy of Jane (Luzadder) LaMaster.)

This photograph was taken of the New Carlisle Post Office on the north side of Michigan Street east of Arch Street on its last day of operation, January 31, 1964. A new post office was constructed on Chestnut Street. The first post office in New Carlisle was established on February 25, 1837. (HNC.)

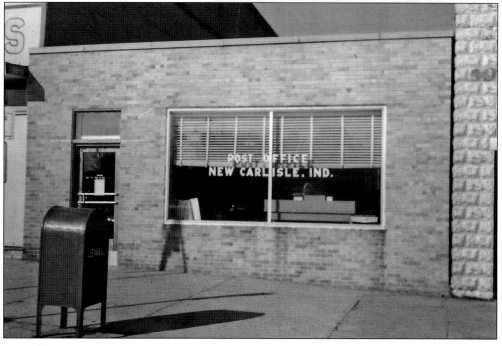

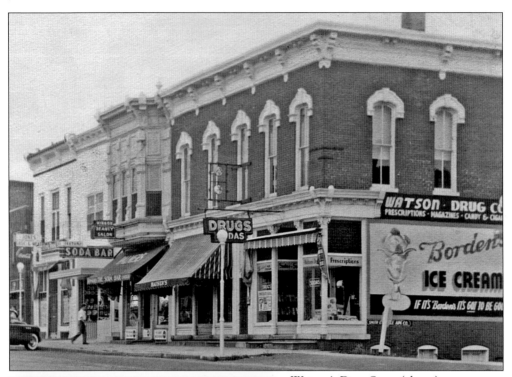

Watson's Drug Store (above) was established in 1949 when Glen and Winnie Watson purchased the store on the northwest corner of Michigan and Arch Streets. Glen was a pharmacist and Winnie (left), despite being a full-time elementary teacher, was also active in the business. She began a gift department in the store, and just before the world of collector plates became the rage in 1970, Winnie decided to sell the artistic plates in the store. Glen died in 1973, and by 1975, Winnie closed the pharmacy and Watson's became a collectible store. That same year Winnie founded the International Plate and Collectibles Exposition. Thousands of people traveled to New Carlisle each year during the South Bend event to visit the store. After nearly 50 years, Winnie sold her store and retired. Her buildings became part of Bill Sutton's Village Shoppes. (Both courtesy of Pat Tolmen.)

Six

RELIGIOUS PURSUITS

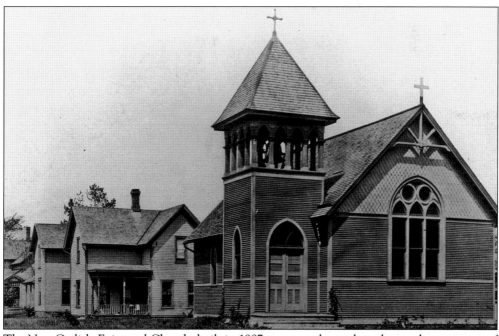

The New Carlisle Episcopal Church, built in 1887, was once located on the northwest corner of Filbert and Ada Streets. The church was later moved to East Chicago, Indiana, where it continued as a house of prayer. The wood-frame building featured a prominent bell tower as well as Gothic Revival influences, such as the pointed arch windows and doorway. (HNC.)

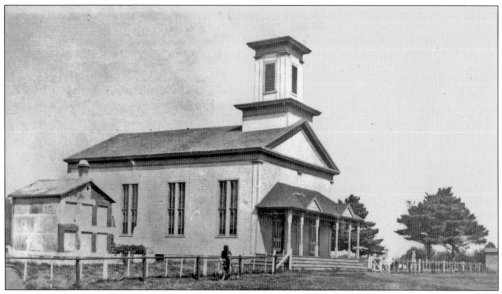

The first meeting of the Hamilton Church was held in 1830 at the home of Paul Egbert, a Methodist preacher. A building was started in 1837, but it burned down before it was completed. The present church building was constructed in 1838 by architect Oliver Emery. The church was dedicated in 1843. It is thought to be the oldest Methodist church building in use north of the Wabash River. (HNC.)

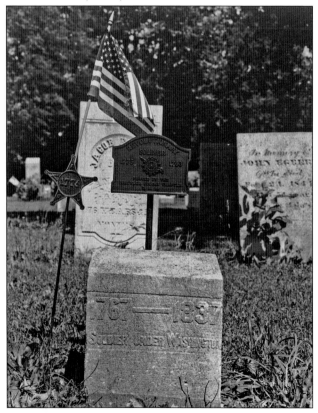

James Ranstead, who served as an aide for George Washington, is one of two Revolutionary War soldiers buried in Hamilton Cemetery. The cemetery is home to several veterans from every war that the United States has been involved in including the French and Indian War, Revolutionary War, War of 1812, Civil War, World War I, and World War II. Joseph Hursch, whose life spanned three centuries, is also buried at the cemetery. Hursch was born in 1793 and died in 1903. (HNC.)

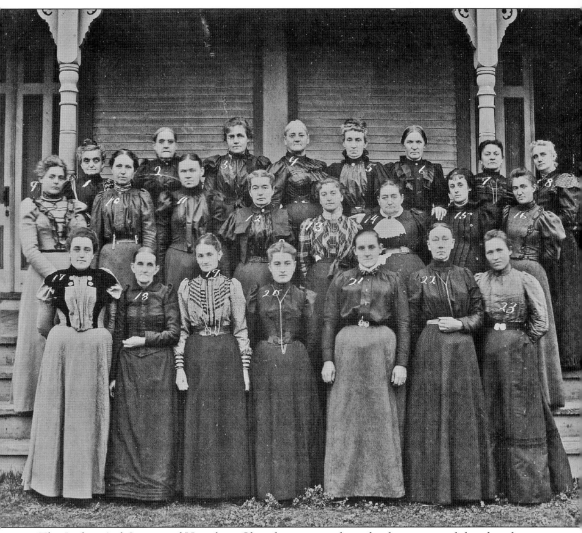

The Ladies Aid Society of Hamilton Church is pictured on the front steps of the church in 1898. Pictured are, from left to right, (first row) Louise Wykoff, Elzina Myers, Arminia Hubbard, Kate Reynolds, Olive Lauver, Harriet McBain, and Anna Proud; (second row) Emma Ranstead, Ida Anderson, Mrs. John Benjamin, Ellen Hentzelman, Florence Davidson, Mary Ann Wykoff, Nellie Barnes, and Edith Borden; (third row) Emma Shimp, Mary Faurote, Laura Smith, Hannah Reynolds, Alice Wykoff, Mrs. Gustafson, Millie Rittinger, and Anna Wykoff. In 1864, earlier members of the Hamilton Church Ladies Aid Society made a U.S. flag with appliquéd stars and a golden eagle that was used during one of Abraham Lincoln's campaigns. The flag measures 8 feet high by 11 feet wide and hangs in the vestibule of Hamilton Church. It is thought to be the oldest flag in continuous use in the state of Indiana. (Courtesy of Hamilton Church.)

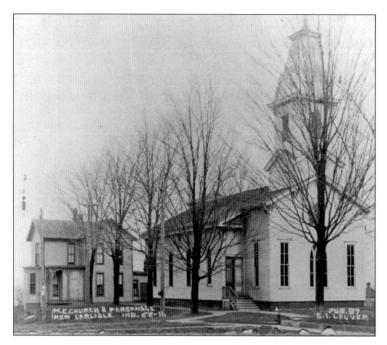

The First Methodist Church was organized as part of the South Bend circuit, and early organizers met in homes and buildings until a church could be constructed to accommodate regular worship services. The church at the northeast corner of Front and Cherry Streets was constructed in 1858, and the parsonage was built in 1881. In 1886, lightening struck the church, demolishing the steeple. For lack of funds, it was never rebuilt. (HNC.)

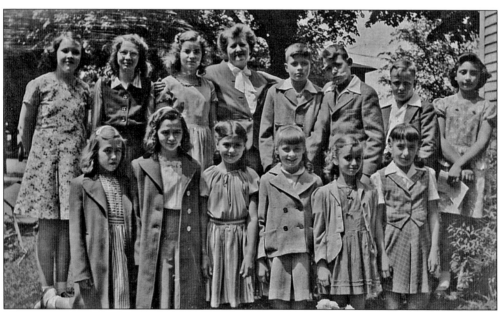

The 1946 First Methodist Church Sunday School class was taught by Margaret Ekstrom. Pictured are, from left to right, (first row) Carol Sue Bingaman, Betty Bingaman, Nancy Kelley, Mary Ann Gay, Colletta Wilson, and Ruth Gelow; (second row) Rae Ellen Bickel, Frances Gay, Jane Ann Luzadder, superintendent Sue Murphy, Bob Clapp, Jack Shaw, Johnny Ekstrom, and Carole Sue Gyorgyi. (HNC.)

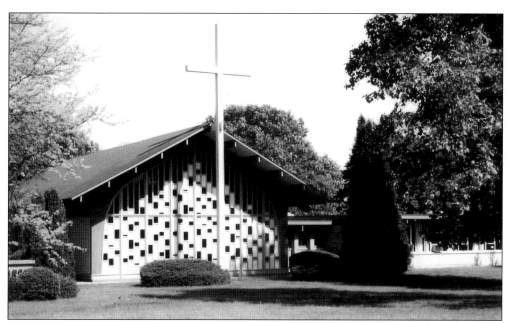

By 1959, the need for a larger church was evident. That year, the congregation voted to purchase a 7-acre site on the corner of Dunn and Timothy Roads in order to construct a new building. On September 13, 1964, the cornerstone for the United Methodist Church building was laid by Rev. Jack Price and Rev. Malcolm McArthur. (HNC.)

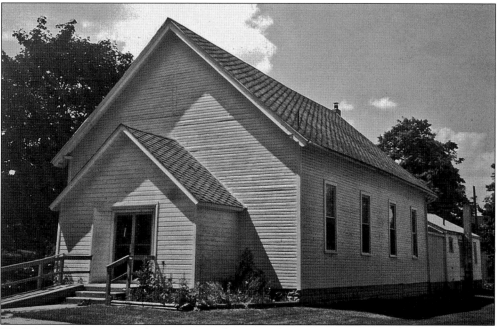

The Pilgrim Holiness Church was organized in 1898 after a series of prayer meetings and a revival under Rev. A. D. Buck converted several people. A church was built on South Timothy Road, and Rev. Etta Innis served as pastor. In 1924, the church moved to New Carlisle to the northeast corner of Arch and Ada Streets. It was later used as a Wesleyan church, and was torn down in 2006. (Courtesy of Mary Ann Swope.)

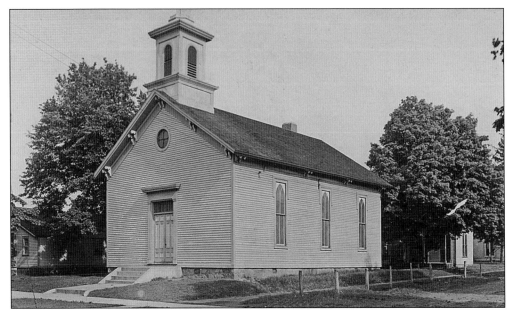

The New Carlisle Christian Church was organized in 1868. The congregation worshipped in each other's homes and later in the Carlisle Collegiate Institute until a church could be built. In 1869–1870, a church building was erected, costing $2,500. The wood-frame structure was built on the site of Lazarus Bourissa's double-pole log cabin and trading post at the northwest corner of Michigan and Cherry Streets. (HNC.)

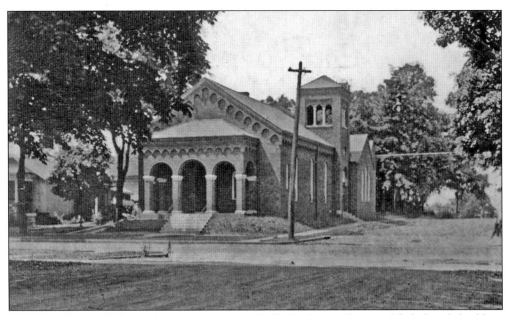

On December 4, 1927, a dedication service was held for the newly remodeled church building renamed the Community Church. Brick was applied directly over the wood-frame structure above. The new building was constructed of brick and limestone and included Venetian-glass windows with ecclesiastical designs at a cost of $27,500. Dr. Raymond Zerby directed the construction and brought change—the church would now be nondenominational. (HNC.)

The New Carlisle Cemetery Association was organized in 1863. Two acres were purchased on the west side of town. In 1870, the cemetery was conveyed by warranty deed to the incorporated Town of New Carlisle. The first burial was of Ida Treadwell in 1863. In 1909, the Deacon Relief Corps No. 48 erected the monument "In memory of the unknown dead soldiers, sailors, and marines of the war of the Rebellion 1861-1865." (Photograph by Everett Dobbins.)

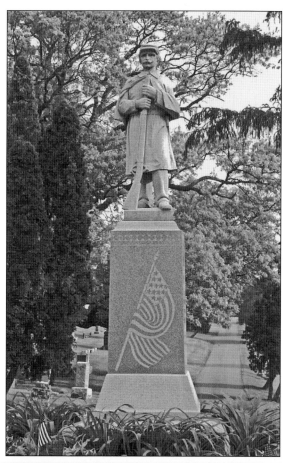

The Olive Chapel Christian Church was organized on January 6, 1842, with six charter members. Those early members attended prayer meetings in the homes of members. At a large revival meeting in 1869, it was decided that the membership was large enough to erect a permanent church building. Joseph Adams donated land at a cost of $1,900. The dedication took place on October 16, 1869. (Courtesy of Diane Melady.)

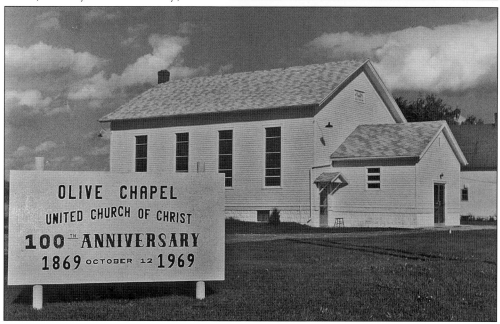

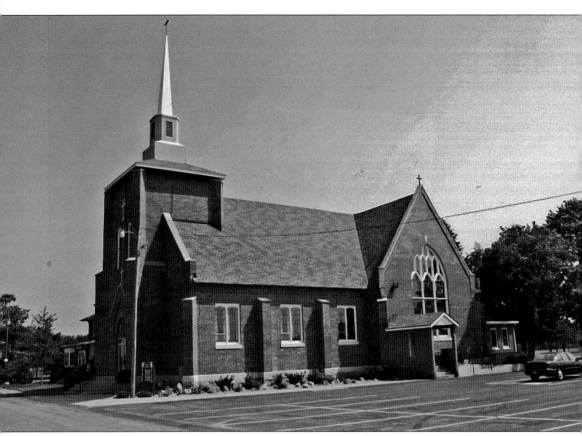

St. Stanislaus Kostka Catholic Church was built in 1884. Fr. Valentine Czyzewski, pastor of St. Hedwig, established the church for the growing Terre Coupee area. The wood-frame structure was dedicated on Sunday, August 31, 1884. Fred Miller donated lumber from his sawmill, and parishioners donated their time to construct the church at a cost of $1,800. The need for a larger church was evident by 1903, and in August of that year, the cornerstone was laid. The new brick church was built in the Gothic Revival style and was completed in 1906. The old wood-frame church served as a parochial school until it burned down in 1908. Fr. John Wroblewski served as pastor for 20 years beginning in 1932. Father Wroblewski showed his artistic talents by creating a beautiful rock garden. The garden had an artificial brook and lagoons along with many plants and flowers. A rectory was built in 1927 and a reception hall in 1964. (Photograph by Everett Dobbins.)

Seven

SCHOOL DAYS

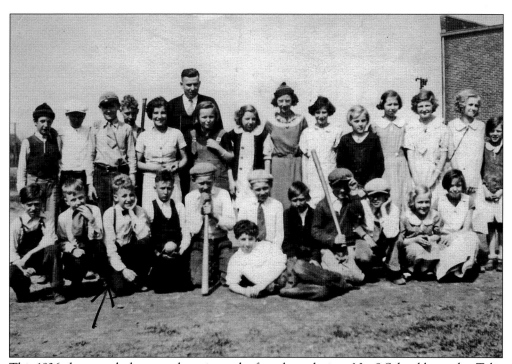

This 1936 photograph shows students in grades four through six at No. 9 School located at Tulip and Filmore Roads. The school was built in 1927 and was the last county school to close in 1952 in an effort to consolidate and move all students to the New Carlisle schools. Leo Golubski taught at the school the entire time. (Courtesy of Pat Wolf.)

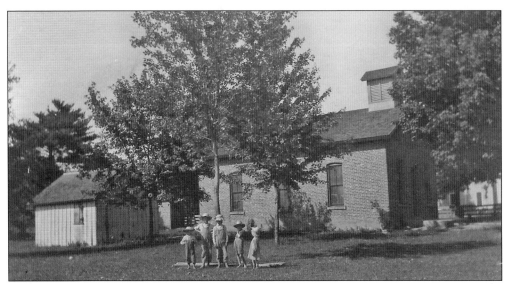

Hamilton School was built in 1876 by Thomas Jefferson Garoutte and was the oldest of the district schoolhouses. The school was located just a couple hundred feet from Hamilton Church. The schoolhouse had a low stage built across the front where the teacher's desk sat. In 1930–1931, the school was given back to A. B. Wykoff, the owner of the land, who converted it into a home. (Courtesy of Paula Romig.)

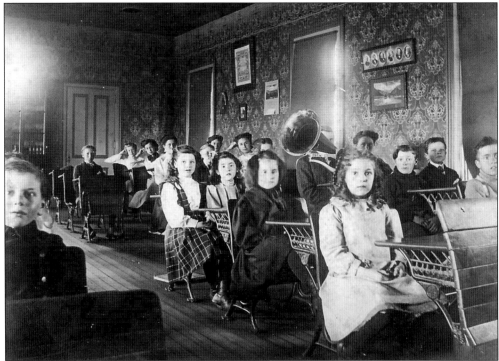

Children at Puddletown School took a break from their school work to pose for this photograph. Puddletown was one of many one-room schools that served the rural population. Originally located on State Road 2, the school was later moved and still stands at 700 East and 350 North. Gladys Tolmen is the third girl back on the aisle.

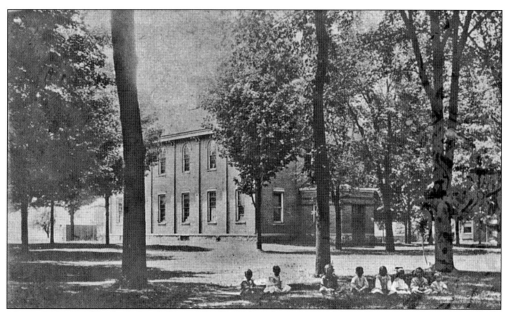

The Northwest Conference of the Methodist Church recognized the need for higher education in preparing students for college. In 1860, Methodist Rev. John Leach was given the task of establishing a school in New Carlisle. A public meeting was held in December 1860, and the Carlisle Collegiate Institute was conceived. In 1861, Joseph Ivins donated 2 acres of land for the school. A new school building was completed, and school commenced on September 24, 1861. The following quote is taken from *A Short History of the Schools of New Carlisle* written by Anna Rittinger: "The building is situated in the center of a beautiful square enclosed with a neat picket fence with an arched gateway and double gates in front, and diagonal corner gates." (Both HNC.)

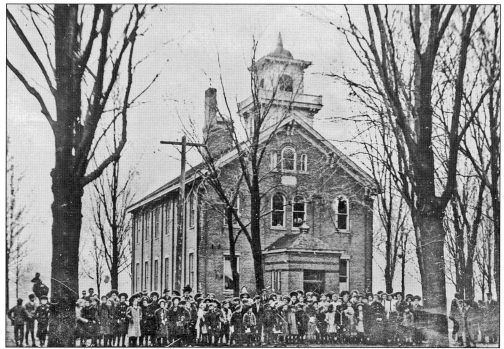

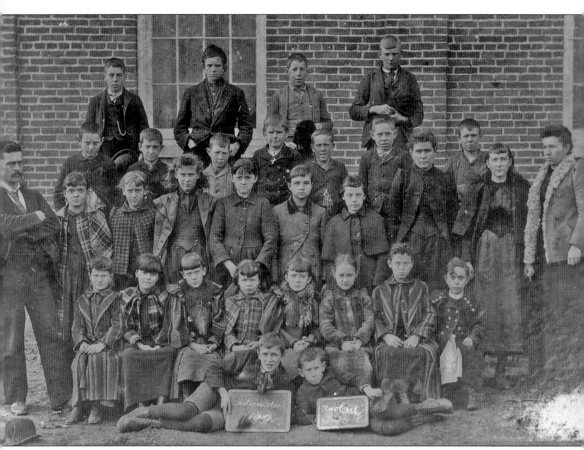

The Intermediate Department of the Carlisle Collegiate Institute in 1892 included, from left to right, (first row) Marvin ? and Eddie Curtain; (second row) Clara Terpany, Nett White, Annie Service, Wilma McDaniel, Lizzie Service, Grace Griffith, Myrtle Terpany, and Bessie Freeland; (third row) Prof. Searles, Alice Compton, Louisa Kratz, Ada Salloway, Daisy Stinchcomb, Daisy Miller, Ollie Stockton, Laura Sprague, Dora Tippy, and unidentified; (fourth row) Charles Rayborn, Clyde Catterlin, Nelson Miller, Jerry Stockton, Charles Brockway, Charles Sprague, and Clyde Richardson; (fifth row) Fred Steep, Jim Miller, Clate Hosetter, and Art Salloway. In 1878, prior to this photograph, the Town of New Carlisle had purchased the school building. In 1903, a law was passed to allow townships to hold school property in an incorporated town. The school was then deeded to the township. The high school was commissioned just a year before, in 1902. (HNC.)

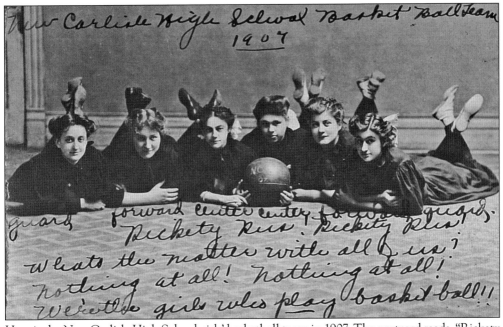

New Carlisle High School Basket Ball Team
1907

guard forward center center forward guard
Rickety Rus! Rickety Rus!
What's the matter with all of us?
nothing at all! nothing at all!
We're the girls who play basket ball!!

Here is the New Carlisle High School girls' basketball team in 1907. The postcard reads, "Rickety Rus! Rickety Rus! What's the matter with all of us? Nothing at all! Nothing at all! We're the girls who play basketball!" Girls' basketball was a very popular high school sport in the early 1900s. (Courtesy of Joan Wilson.)

In 1911, an addition was built to the east of the Carlisle Collegiate Institute. The addition included a new auditorium as well as high school rooms including a chemistry laboratory. With increased enrollment, the need for more classrooms was evident. The primary grades continued classes in the Carlisle Collegiate Institute building while the high school classes moved to the new addition. (Courtesy of Paula Romig.)

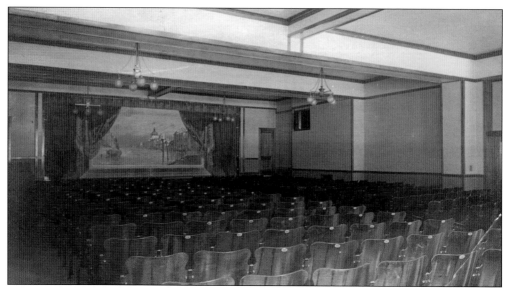

The interior of the high school auditorium included a stage, scenery, and modern equipment. The auditorium was used for class plays, meetings, and many other activities and could seat 300 people. The auditorium was later used as a study hall after the gymnasium was added in 1939. (Courtesy of Paula Romig.)

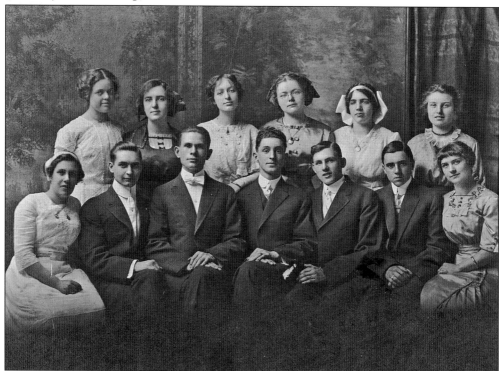

Featured here is the New Carlisle High School class of 1913. From left to right are (sitting) Blanch (Osborn) Jones, Frank Bleasdale, Larue Luther, William Hooton, Horace Garoutte, Webster Carr, and Mary Ellen (Wykoff) Bleasdale; (standing) Lucille (Hooten) Depoy, Jane Walker, Irene Roloff, Phyllis (Miller) Hibbs, Marguerite (Osborn) Brewer, and Mildred (White) Bunton. (HNC.)

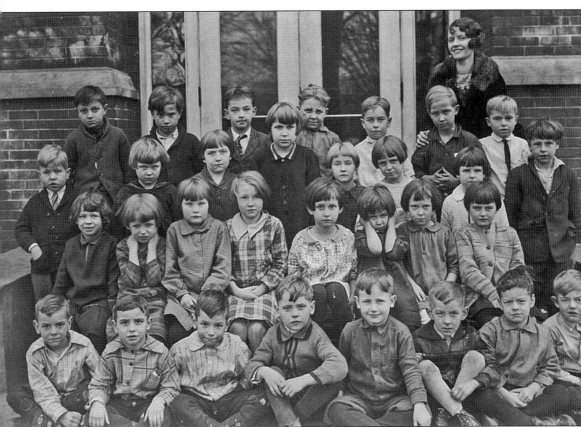

Students from the primary room in New Carlisle from 1927 are, from left to right, (first row) Max Jettner, Junior Bennitt, Guy Jettner, Raymond Stevens, Duane Melady, Jack Hauser, Donald Cripe, and Richard Depoy; (second row) Thomas Baer, Betty Hooten, Louise Ray, Nathalie Fowler, Bulah Keltz, Jean Ann Sharp, Virginia Shirrow, Elthea Swank, and Sadie Mae Bunton; (third row) Mary Smith, Stella Wroblewski, Stella Marshall, Marjorie Wetzel, Laura Arnold, Liona Hullinger, and Kenneth Dokey; (fourth row) Andrew Nagy, Robert Sult, Quentin Swank, Merle Wining, Floyd Runnels, Frank Pruszkowski, and Harold Runnels. The class is pictured with their teacher, Alta Mae Taylor, who served as an elementary school teacher for over 40 years. Five children who were absent the day of the class picture were Charm Green, Frank Rose, Leo Janowkowski, Rosalie Hawkins, and Lott Pruszkowski. (HNC.)

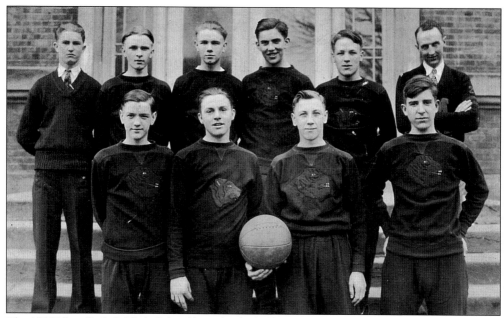

The 1929 New Carlisle High School boys' basketball team poses for a picture in front of the high school. Pictured are, from left to right, (first row) ? Jettner, Jim Runnels, Carl Ekstrom, and Warren Hooton; (second row) manager Fred Nickerson, Joe Danielson, Lee Stockton, ? Doreman, Ray Carlson, and coach Edwin Comer. (HNC.)

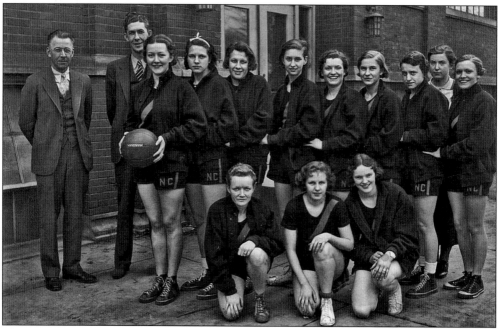

The 1934–1935 New Carlisle High School girls' basketball team is pictured in front of the school. Pictured are, from left to right, (first row) Virginia McCreary, Mabel Perry, and Virginia Jones; (second row) principal Pat Murphy, coach Harry Oglesby, Grace (Hall) France, Frances Lindsey, Margaurite Milliken, Jean Ann (Sharp) Harding, Mary Alice (Rodgers) Horvath, Jean Smith, Marjorie Trumble, assistant coach Betty Hillier, and Vivian (Rodgers) Purvis. (HNC.)

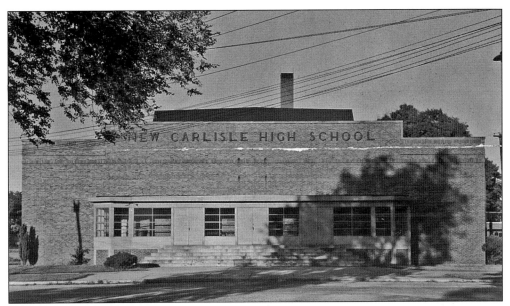

The new gymnasium addition, which also included shop, home economics, and band rooms, was added to the school in 1939. The gym was the scene of many great basketball games, and the New Carlisle fans were some of the best in cheering on the Tigers to victory. The gymnasium was also used for graduation commencements and other school and community activities. (HNC.)

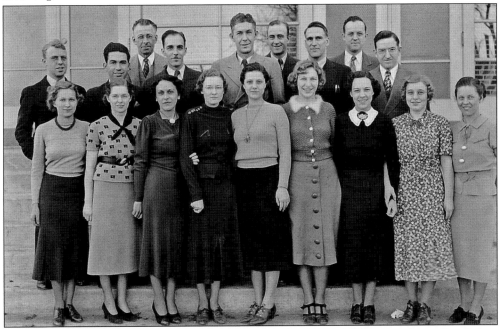

New Carlisle High School faculty members pose for a picture in 1937. Pictured are, from left to right, (first row) Mildred Bauer, Madeline (Bowers) Bonham, unidentified, Adah Ruth (Rodgers) Weaver, Mary (Cauble) Brummitt, Thelma (Schulfer) Horvath, Adeline Magnabosco, Mabel Irene (Bunton) Grimes, and Mary Alice (Zigler) Brittan; (second row) Elroy "Limey" Brittan, LeRoy Stutsman, A. E. Murphy, Dick Bonham, Harry Oglesby, Orrin Shaw, Darle Pfeiffer, Clyde Nice, and Millard Taylor. (HNC.)

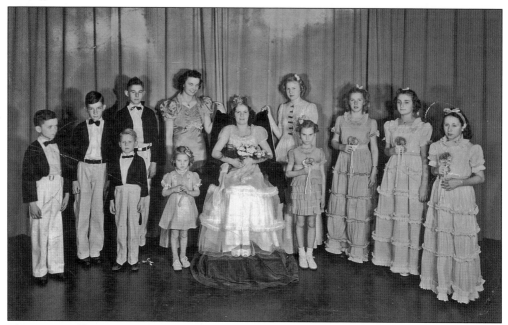

The queen and her court of the 1939 Halloween Festival include, from left to right, Jack Shearer, Lewis Mounts, Bob Amen, Alice Davenport, Geraldine Miller (queen), Reva Luther, Dolores Casaday, June Brummitt, and Marilyn Kern. Standing in front from left to right are Stuart Clark, unidentified, and Betty Kulwicki. Several of the girl's dresses were made out of crepe paper. (Courtesy of Betty Johnson.)

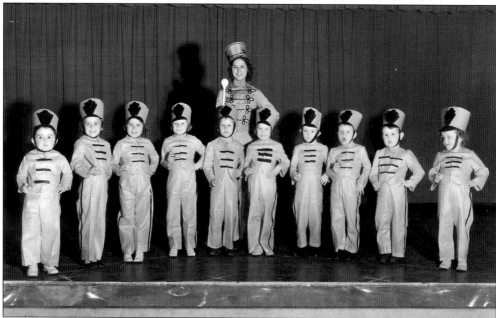

The 1939 New Carlisle midget twirlers are pictured with their instructor, Aileen Luther. Pictured from left to right are Gene Goad, Shirley Kleine, Jane Ann Luzadder, Evelyn Meyers, Stuart Clark, Frances Gay, Reed Taylor, Bob Clapp, Jack Shaw, and Ruth Ann Harrington. Ruth (Harrington) McQueeney remembers her mother making most of the uniforms for the children. (Courtesy of Gladys Morse.)

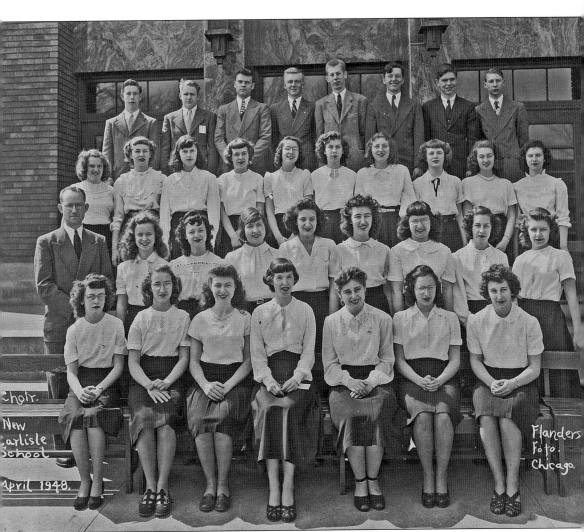

Shown here is the 1948 New Carlisle High School choir. Included in the photograph are, from left to right, (first row) Shirley Kleine, Marilyn Stockton, Marcella Miller, Eileen Snodgrass, Jean Marie DuBois, Joan McPherson, and Mary Milliken; (second row) teacher Wilbur Eslinger, Catherine Wolfe, Sally Long, Patsy Clark, Donna Phillips, Pat Humphrey, Modelle Tolmen, June Tarr, and Marilyn Paxton; (third row) Laverne Spitz, Zora Zolman, Margie West, Norma Ray, Ruth Ann Smith, Jeri Spickler, Grace Rader, Mary Wilson, Joyce Hutchinson, and Joan Dudeck; (fourth row) Johnny Colburn, Gene Curtis, Jim Wilson, Carlyle Saylor, Hugh Burch, John Zdankus, Albert Eckert, and Norris Hooton. (HNC.)

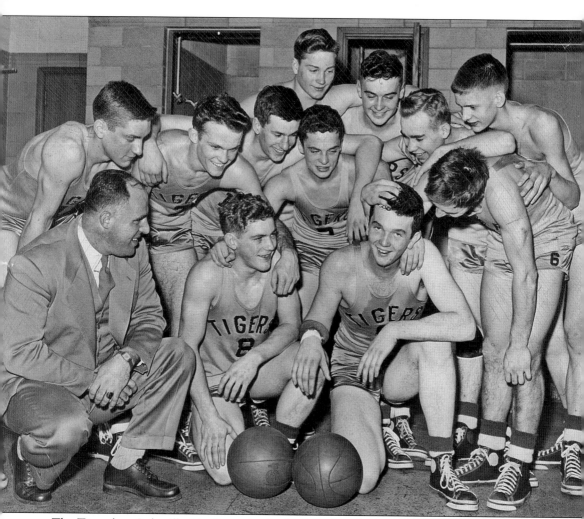

The Tigers beat Lakeville 54–49 to win the 1948 St. Joseph County basketball championship. Pictured are, from left to right, (first row) coach Loyal Marker, Joe Stayback, Jack Palmer, and Russell Flatt; (second row) Jack Marshall, Jim Agness, Mark Hooten, Gene "Chico" Levan, Ralph "Bud" Taelman, and Bruce Sharp; (third row) George Degler and Walt Wilson. (HNC.)

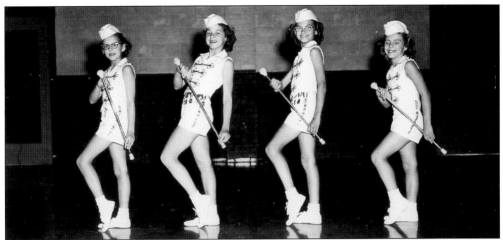

Members of the 1951–1952 New Carlisle High School band baton twirlers are (left to right) Janice Ray, Ann-Nita Ekstrom, Carolyn Brummitt, and Nancy Moffitt. Ann-Nita Ekstrom, a competitive baton twirler, was named Outstanding Juvenile Twirler in the United States in 1949 and Indiana State Champion in 1952 and, in 1954, she won the Midwest High School Championship. At the age of 15, Ann-Nita became the Senior National Baton Twirling Champion and was named to the Baton Twirlers Hall of Fame. (HNC.)

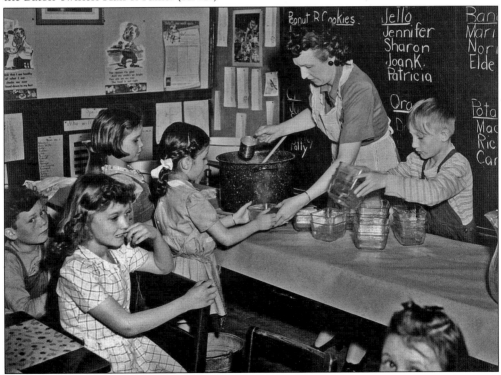

Martha (Rodgers) Holaday was a teacher for 40 years in the Olive Township schools. She taught second grade in New Carlisle from 1927 to 1930 and first, second, and third grades at the No. 9 school from 1935 to 1941. She returned to New Carlisle and taught second grade from 1941 to 1972. She is remembered by her students for teaching them to make soup and Jell-O and how to churn butter. She retired in 1972. (HNC.)

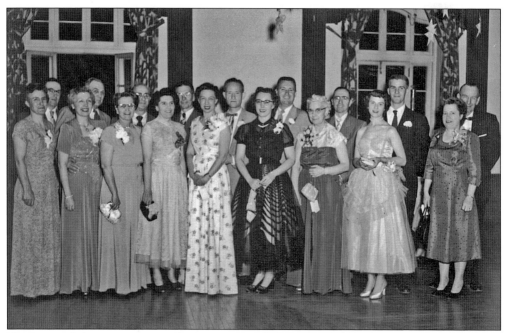

Teachers and their spouses pose for a picture at what appears to be a dance or prom during the 1953–1954 school year. From left to right are Magdalene and Millard Taylor, Martha and Orlo Holaday, Garnett and Orrin Shaw, Wilhelmina and George Troeger, Annie and Wilbur Eslinger, Lorene and Harry Stoneburner, Inez and Webster Carr, Phyllis and Wally Sacks, and Dorothy and Ed Penick. (Courtesy of Dick and Judy Taylor.)

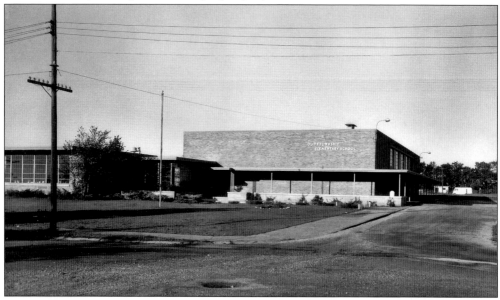

The need for a new elementary school was evident by 1952. Plans got under way, and a new school was constructed 600 feet south of the high school at a cost of $450,000. The Olive Township elementary school was dedicated on December 12, 1954. Webster Carr, a 1913 New Carlisle graduate, served as the first principal. The school was replaced by a new elementary school in 1995. (Courtesy of Max Haag.)

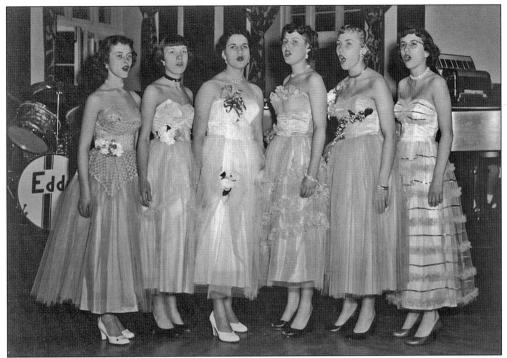

Pictured are, from left to right, Norma Hooton, Connie Lindsey, Eleanor Hampshire, Patty West, Pat Swartz, and Ruth Gelow. The group of girls named the *Six Sharps* sang at the 1954 New Carlisle junior-senior prom and entertained locally in nursing homes and other venues during the same period. (HNC.)

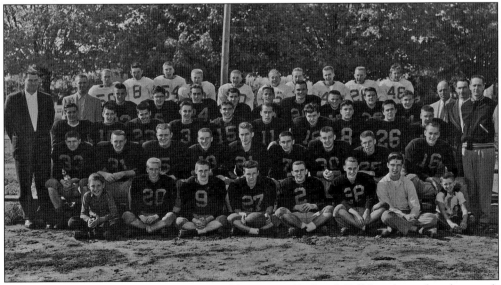

New Carlisle's first football team is pictured here in 1955. Coach Bill Lynch was hired to teach the game of football, leading the Tigers to a 3-2 record. The first game was played on September 17, 1955, against Jimtown, with New Carlisle winning 13–0. A new football field was constructed in 1956 under the leadership of the New Carlisle Lions Club with the help of other organizations and individuals. (HNC.)

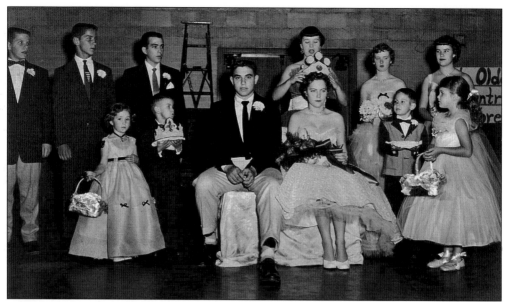

Members of the 1955 Fall Festival court are, from left to right, (front row) Brenda Cox, Joseph Knoblock, John Bingaman (king), Toby Smith (queen), Greg Hafstrom, and Linda Tolmen; (back row) Butch O'Shea, Jim Viscik, John Talerico, Jackie Budny, Marilyn Robinson, and Jan Davis. The annual Fall Festival was a much-anticipated event each year. (Courtesy of Brenda Moffitt.)

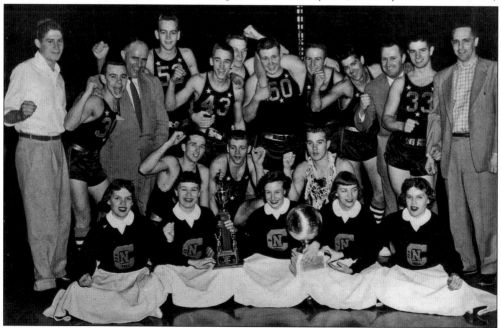

The Tigers defeated North Liberty 47–44 to win the 1955 St. Joseph County Basketball Championship. Pictured are, from left to right, (first row) Beverly Fisher, Jackie Budny, Marilyn Hoover, Martha Sebasty, and Barbara Fisher; (second row) Dan Milliken, Leon Adnson, and Charles Gregory; (third row) Merlin Doba, Darle Hoover, coach Loyal Marker, Jerry Degler, Jim Rodgers, Don Kulwicki, Charles Kring, Richard Zielinski, Bill Anderson, principal Harry Stoneburner, Harry Tolmen, and coach Jack Allen. (HNC.)

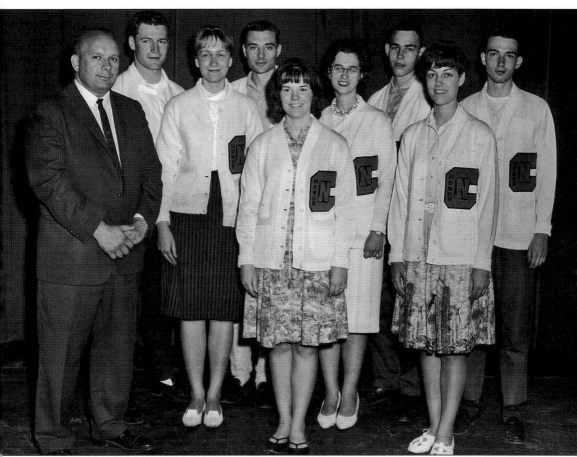

The first scholastic letter sweaters were given to New Carlisle High School students in 1963. Pictured are, from left to right, principal Amzie K. Miller, Carl Meyers, Barbara Benjamin, Don Heinek, Carolyn Nicodemus, Gretchen Downey, Russell Barnes, Pamela Wykoff, and Burdette Casaday. (HNC.)

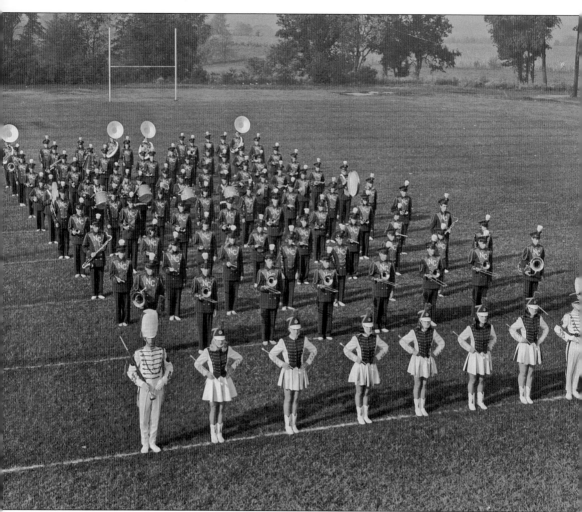

The 1965 New Carlisle High School marching band is shown practicing on the football field. In the background is Bourissa Hills Park. A very talented band, it won first place and $1,000 at the Partners in Progress contest in September 1964 in South Bend and placed 19th at the Indiana State Fair under the direction of Kenneth Johns. (HNC.)

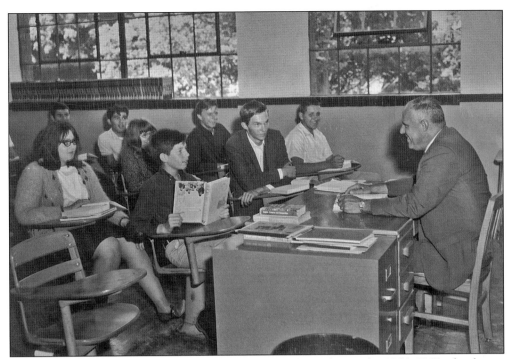

Loyal Marker is pictured in his classroom with his students during the 1966–1967 school year. Marker's classroom was located just west of the office. He taught mathematics and was a successful coach at New Carlisle, winning the county basketball tourney in 1948 and again in 1955. Marker was a teacher for over 30 years. (Courtesy of Mary Margaret Marker.)

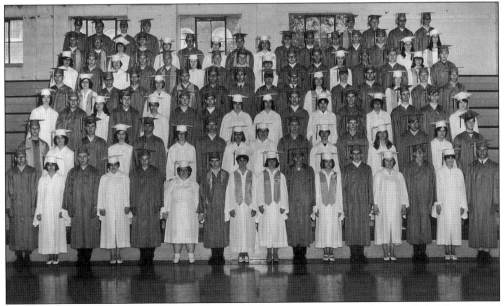

The class of 1968 is pictured in the high school gymnasium on graduation day. The class of 1968 was the last class to graduate from New Carlisle High School. The class of 1969 started the year at the old school and moved midyear to the new high school that was built west of town. (Courtesy of Brenda Moffitt.)

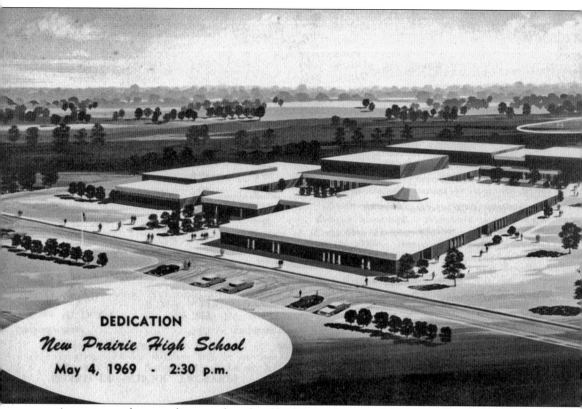

DEDICATION
New Prairie High School
May 4, 1969 · 2:30 p.m.

A growing student population and outdated buildings were part of the reason that the communities of New Carlisle and Rolling Prairie decided to merge their high schools together. The New Carlisle Tigers and the Rolling Prairie Bulldogs consolidated as the New Prairie Cougars. The new school was built about 2 miles west of New Carlisle and was dedicated on May 4, 1969. The old New Carlisle High School building continued in use as the junior high until it was torn down in 1981 and a new junior high was built adjacent to the new high school. The four elementary schools of Olive, Hudson Lake, Rolling Prairie, and Galena fed into the junior high and high school. The site of the old school was dedicated as Memorial Park. The park has served as a venue for many community events throughout the years, just as the old high school had for many years. (HNC.)

Eight

LAKE RESORT

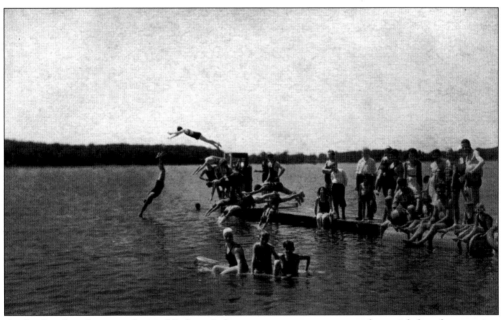

At the height of its popularity, Hudson Lake was a resort mecca complete with hotels, camping and picnic grounds, swimming, boating, dancing, and much more. The casino provided live music every night of the week except Mondays and brought trainloads of visitors to dance the night away. Hudson Lake was also the ideal spot for family reunions and large company picnics. (Courtesy of Paul Romig.)

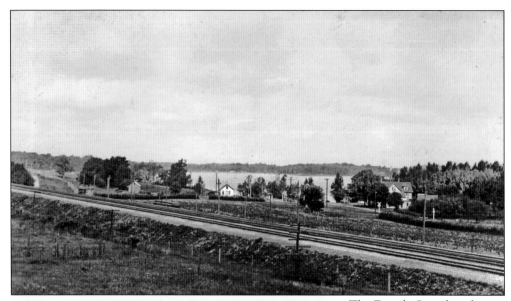

The French-Canadian fur traders named Hudson Lake *"Lac Du Chemin,"* which means Lake of the Road. The main route of travel was the Chicago-Detroit Road that passed around the east side of the lake. Settlement began in the 1830s, and by 1835, the village of Lakeport, as it was first called, had a post office, two taverns, and a stagecoach stop. (Courtesy of Joan Wilson.)

William J. Smith and his wife, Avella, were instrumental in popularizing Hudson Lake as an appealing summer resort. Smith built the Hotel Hudson in 1885 and constructed a general store as well as a boat dock and cottages. Smith later built Hudson Lake Casino and brought in live bands that attracted many people from neighboring cities as well as Chicago. (Courtesy of Joan Wilson.)

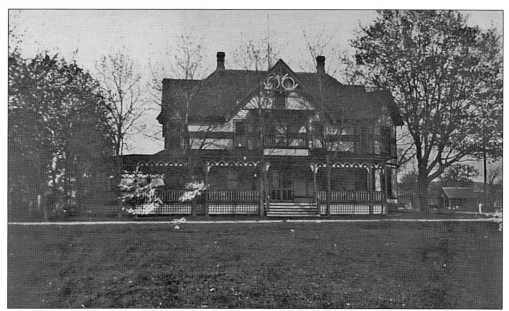

The Hotel Hudson was constructed in the Queen Anne style by William and Avella Smith in 1885. The hotel was built across the road from the lake near the railroad tracks. The hotel boasted 30 rooms and rates by the day or week. At the rear of the hotel was a barn for the customers' horses, and the second floor was used as a dormitory for the employees. (Courtesy of Joan Wilson.)

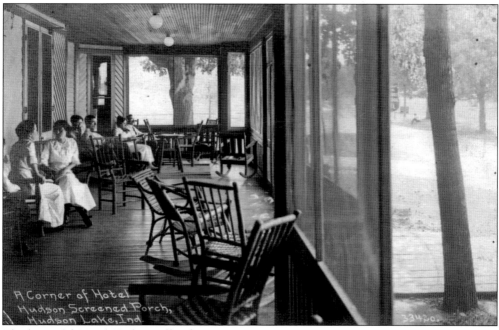

The beautiful Hotel Hudson offered many amenities to its guests. Guests enjoyed visiting and relaxing in the screened-in porch, which afforded a great view of the lake. Visitors came from nearby cities such as South Bend, LaPorte, and Michigan City as well as from Chicago to relax and enjoy the beautiful scenery. (HNC.)

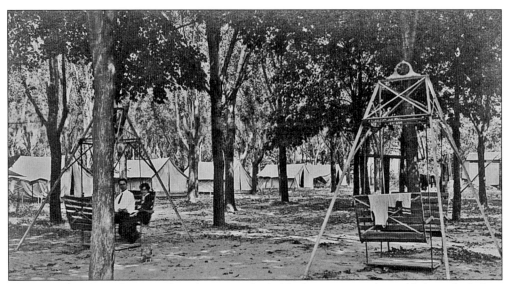

The grounds surrounding Hotel Hudson were shaded by large trees and provided an ideal place for family and company picnics as well as camping and other recreational activities. Guests are pictured enjoying the swings located next to the hotel. Several tents are lined up in the background. (Courtesy of Joan Wilson.)

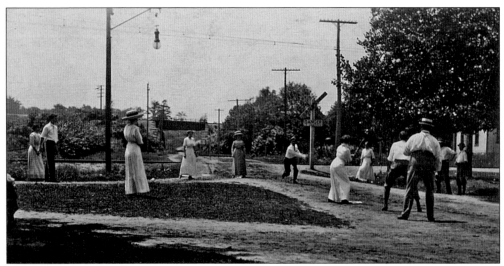

Visitors to Hudson Lake enjoyed many recreational activities. Shown here, some young men and women enjoy playing a game of baseball in the dirt street just north of the railroad tracks. William and Avella Smith's home is barely visible in the background to the south of the tracks. The house still stands today. (Courtesy of Joan Wilson.)

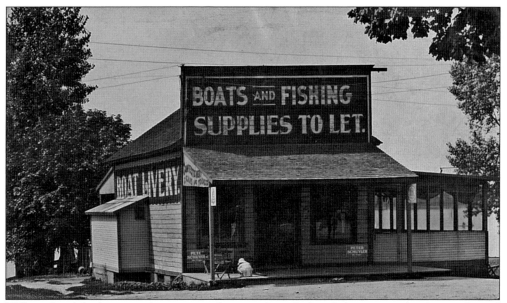

William Smith built a general store across the street from the hotel. A report on the progress showed up in the *St. Joe Valley Weekly Register* dated May 21, 1884. It read, "Mr. William and Charles Smith are hurrying up their store building at Hudson Lake, intending to have it in running order early in June." Smith moved the store in 1914 to make way for a new casino building. (Courtesy of Joan Wilson.)

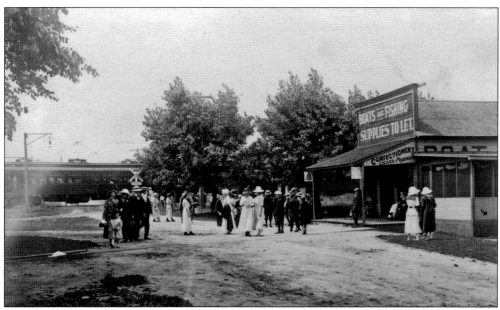

Hudson Lake vacationers are shown getting on and off the South Shore train. The South Shore Railroad was built in 1908 and operated through Hudson Lake and, soon after, on to Chicago. That mode of transportation was responsible for bringing thousands of visitors to Hudson Lake each summer to enjoy all that the lake and resort areas had to offer. (Courtesy of Joan Wilson.)

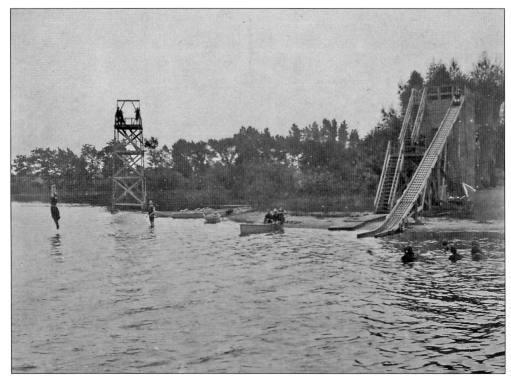

While Hudson Lake was promoted for company picnics and reunions, the lake was the main source of entertainment for many. Swimming, boating, and fishing were popular activities. A wooden slide believed to be located at Lake Park was built and must have been quite a thrill for kids to slide down. (Courtesy of Joan Wilson.)

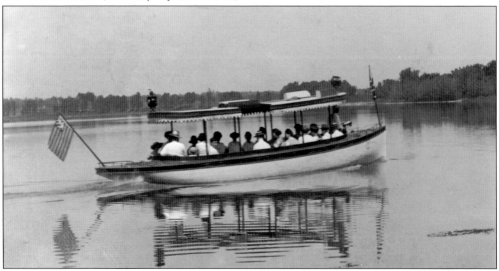

Pleasure seekers enjoy a beautiful day on the lake. A steamboat would take people on excursions around the lake and to the island for a great view of the surrounding lake and countryside. A quote from the September 20, 1882, *St. Joseph Valley Weekly Register* stated, "The steamer Nettie Jane, on Hudson Lake was very busy again last Sunday carrying excursionists and pleasure seekers." (Courtesy of Joan Wilson.)

In 1914, William Smith moved his general store and built the Hudson Lake Casino on the site across the street from the hotel. The casino had a large dance floor and stage. There was a snack bar and marble soda fountain. After World War I, the Smiths brought in jazz bands for entertainment. There was no admission charge to the casino. The entertainment was paid for by selling dance tickets. (Courtesy of Paula Romig.)

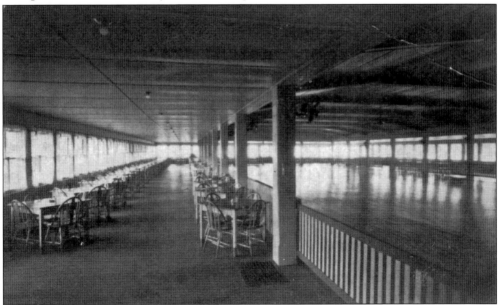

In 1925, the casino was enlarged to 80 feet by 125 feet and improvements were made to the interior. In 1926, the Smith family leased the casino to a Detroit-based band, the Jean Goldkette Orchestra, and it was renamed the "Blue Lantern." The summer of 1926 was a memorable one as the orchestra included famed Bix Biederbecke and other well-known musicians such as Frank Trumbauer and Doc Ryker. Hundreds of people came each night to hear some of the greatest jazz ever played. (Courtesy of Paula Romig.)

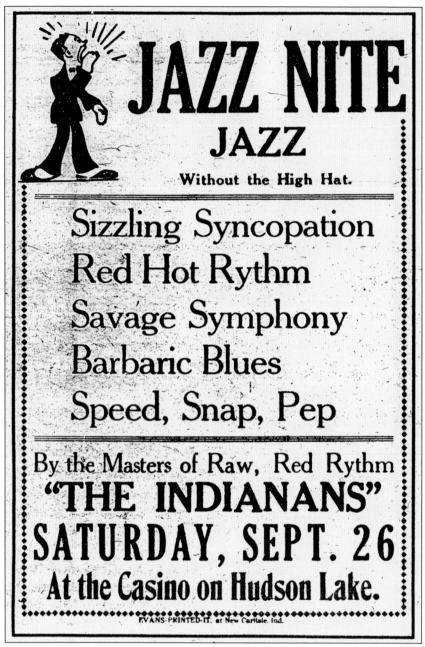

Dancing was held every night at the casino except for Mondays. Lola Trowbridge and the Indianans were local favorites who played at the casino as well as Dexter's Wisconsin Roof Garden Orchestra, Paul Whiteman Orchestra, the Al Ricci Orchestra, and the Rag Pickers Five. Bands continued to play throughout the 1920s and early 1930s, but when the Depression hit, the music stopped. The casino was sold in 1939, and attempts to revive the dancing failed. For a time, the building was used as a roller skating rink and later for boat storage. Much of the land surrounding the casino has been made into a resort trailer park. The casino building has been rehabilitated in recent years with a restaurant in the front. The still-beautiful large dance floor and stage in the rear are rented out for use as a special event facility. (HNC.)

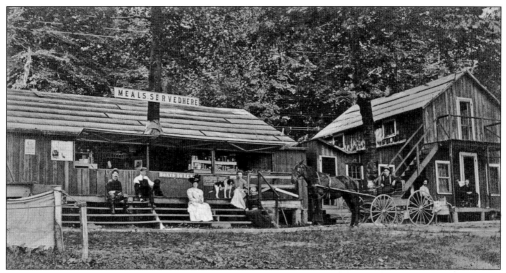

This postcard shows another resort at Hudson Lake called Britton's Resort. The location of Britton's is believed to have been on the north side of the lake near Bluebird Beach. Besides the Hotel Hudson and Britton's Resort, there was the Lake Park Hotel and Pavilion located on the south side of the lake along the South Shore tracks. The dance pavilion was torn down in the 1930s, and the hotel was moved and converted for use as a home. (Courtesy of Paul Wogatzke.)

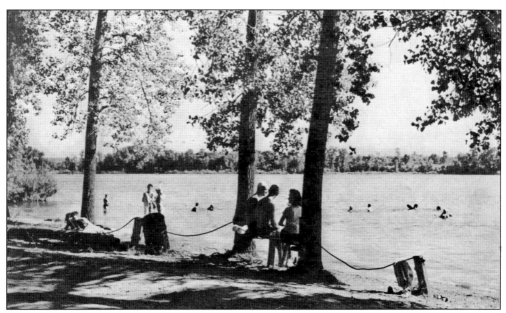

Blue-Bird Beach, located on Lake Shore Drive north of the casino, was another popular place to swim and hang out. Although Hudson Lake has experienced changes from the resort era, many things have remained the same. Hudson Lake has become a community of people who enjoy year-round residence, while also attracting seasonal visitors. The lake continues to provide beauty and entertainment as it always has for swimmers, fishermen, and boaters. (Courtesy of Glory June Greiff.)

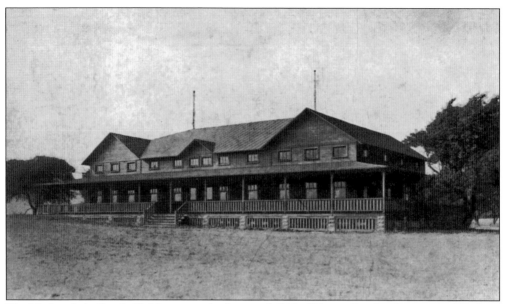

The Hudson Lake Beach Clubhouse was built around 1910 off Emery Road at the corner of Hickory and Poppy Lane during the beginning of the lake's resort popularity. It was built for Chicagoans who owned lake property and spent their summer weekends there. The clubhouse was split up around 1935 and made into three separate homes, two of which remain on the original site. (HNC.)

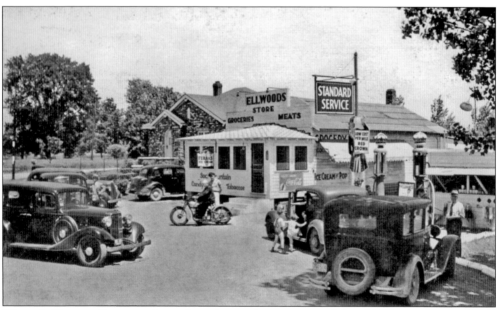

Ellwoods Grocery Store was located on the southeast corner of the old Chicago-Detroit Road and Detroit Street not far from the lake. The little white wood-frame store was a busy place and advertised everything from meat to ice cream, candy, and tobacco. The store also sold Red Crown gas. Two gas pumps are shown in front of the store. (Courtesy of Paula Romig.)

Nine

HAVING FUN

A young man, identified as Walter Beal, stands outside of a downtown building advertising Box Ball Bowling. A bowling lane or alley is visible through the front door. An early form of entertainment, bowling, or "nine-pins," as it was often called, eventually evolved to the 10-pin game we know today. (HNC.)

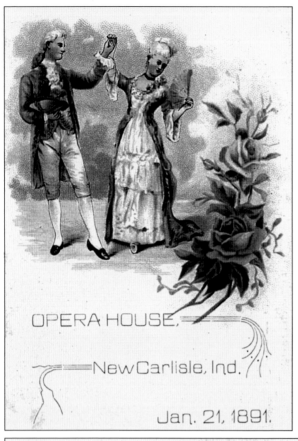

OPERA HOUSE,

New Carlisle, Ind.

Jan. 21, 1891.

The Opera House hosted many events, such as the first Old Folk's Party on January 21, 1891, as this invitation suggests. The Opera House was built in 1873 by William Deacon and Samuel Lancaster. Located on North Michigan Street, east of Arch Street, the building had a seating capacity of 350 on the first floor and 100 on the second floor. The opera house was a venue for many fine shows given by traveling theatrical companies. Along with cultural entertainment, the opera house was used for other activities such as basketball, roller skating, and other sporting events. The building was also used for graduation commencements for many years until the high school constructed its own auditorium. The opera house was torn down in 1953. (Both HNC.)

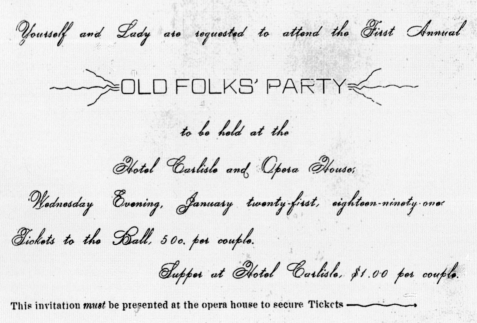

Yourself and Lady are requested to attend the First Annual

OLD FOLKS' PARTY

to be held at the

Hotel Carlisle and Opera House,

Wednesday Evening, January twenty-first, eighteen-ninety-one.

Tickets to the Ball, 50c. per couple.

Supper at Hotel Carlisle, $1.00 per couple.

This invitation **must** be presented at the opera house to secure Tickets ————

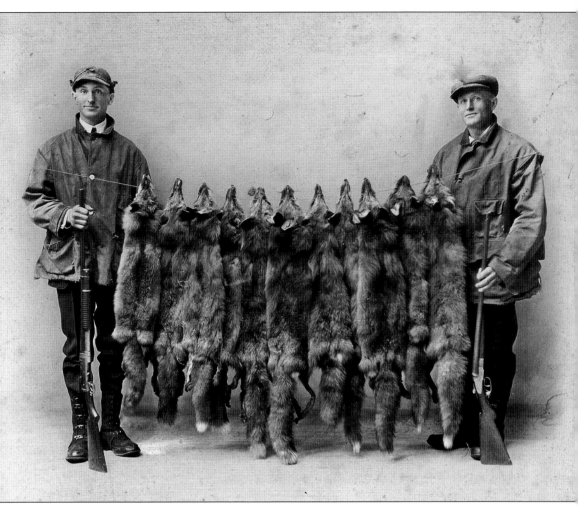

Willie Hooton and Virgil Rodgers show off their successful fox hunt. The two men hunted together often. Hunting was a popular sport for many in the area, as the wetlands, fields, and woods afforded much game. Hunting for geese, duck, and deer as well as fox and rabbit evolved from being a necessity to that of entertainment and recreation. (Courtesy of the Horvath family.)

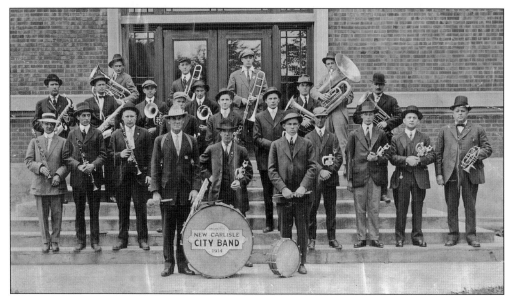

The New Carlisle City Band was organized in 1914. Band members included are, from left to right, (first row) Percy Lauver, Arch Massey, Charlie Baer, Vern Van Dusen, Ray Evans, Paul Garoutte, Fred Brown, Floyd Kuhl, Reverend Aikman, and Roy Brockway; (second row) unidentified, Ross Teeter, and Horace Garoutte; (third row) Charles Brockway, Harry Miller, Jim Uhl, Mervin Crouch, Orville Smith, and George Stockton; (fourth row) Paul Hooten, Howard Brockway, Everett Roloff, and Claude Ackley. (HNC.)

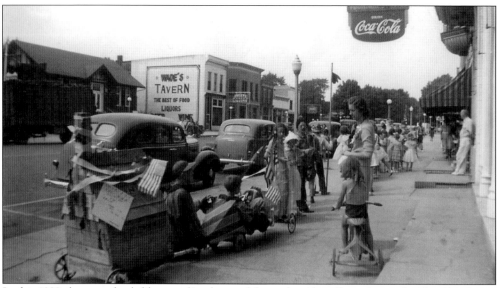

In this 1939 photograph, children are lined up and down the sidewalk on the north side of Michigan Street in downtown New Carlisle. The children appear to be participating in a parade. The Carnegie Library, Wade's Tavern, the bank, and other businesses are visible across the street. (HNC.)

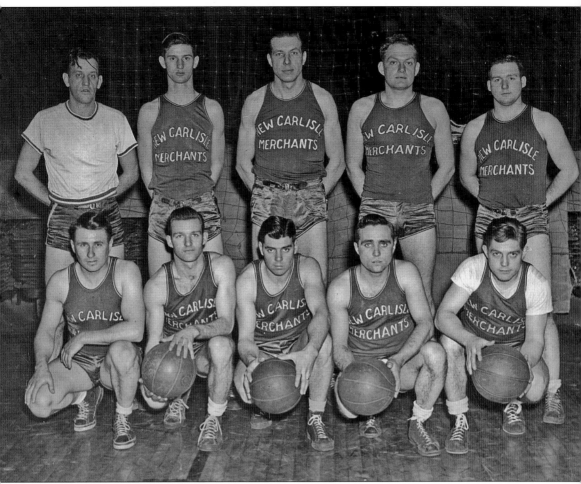

The New Carlisle Merchants' Basketball Team is pictured around 1948. Team members are, from left to right, (first row) Paul Cooreman, Arthur Clark, Bill Carr, Dick Coddens, and Jim Bleasdale; (second row) Dave Stachowski, Calvin Sharp, Kenny Lindsey, Lyle Harding, and Gus Clark. Town merchants and businessmen played teams from the surrounding towns. (HNC.)

The New Carlisle High School band and twirlers march west on Michigan Street toward the cemetery following the annual Memorial Day parade in 1948. Drum majorette Donnie Haag leads the way. The twirlers in the front row are, from left to right, Barbara Eberhart, Judy Clendenen, Ann-Nita Ekstrom, and Carolyn Brummitt. Holding the flags are, from left to right, Mary Ann Gay and Karel Ann Cooper. (HNC.)

Members of the youth bowling league are shown outside of Black Cat Lanes bowling alley in the early 1960s. Black Cat Lanes was opened in 1956 by Norman and Irma Brasseur. Ernie Meyers purchased the bowling alley in 1961, and later his son Carl took over the business and expanded it to include Meyers Ice Cream Shoppe in 1981. The business is now owned by Carl's son, Craig Meyers. (Courtesy of Craig Meyers.)

The team consisting of (left to right) Robert Jones, Ernie Meyers, Chet Jones, Norm Raabe, and Don McGawn participated in the American Bowling Congress Tournament in Toledo, Ohio, in 1960. New Carlisle has produced many good bowlers, and several men's and women's teams have played in tournaments around the country. (Courtesy of Carl Meyers.)

Quarter Midget Races Every Friday

Nite at the American Legion Track.

Time Trials 7 P. M.

Racing starts at 8 P. M.

RAIN DATE SATURDAY NITE

Compliments of

LYLE HARDING Standard Oil Agent

An oval quarter-mile track was built on the American Legion grounds around 1959. Quarter Midget races were held every Friday night through the late 1950s and 1960s. This advertisement is from the July 23, 1959, *New Carlisle News.* The track had bleachers, lights, and a wall around the track displaying local business sponsors. Quarter midget racing is for kids ages 5–16 in scaled-down versions of midget cars. (HNC.)

Mark Miller (below), son of Arnold "Muggs" and Doris Miller, is shown in the forefront in his midget car. The idea of a quarter midget track was conceived by a group of men whose children were all involved in racing. (Courtesy of Arnold "Muggs" Miller.)

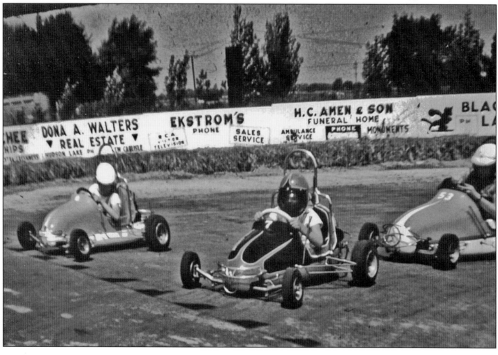

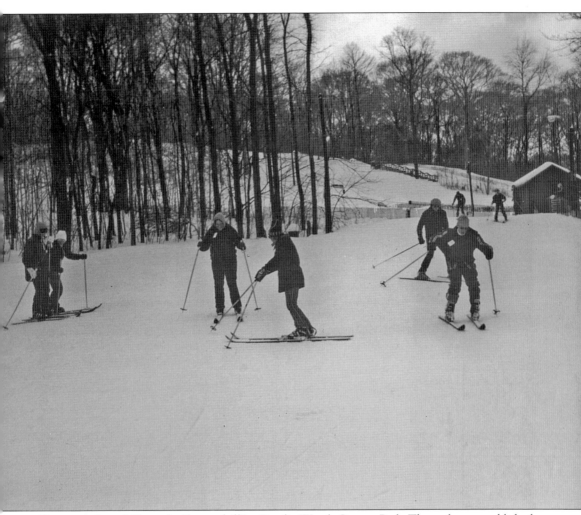

Skiers test their skills on the "bunny hill" at Bendix Woods County Park. The park was established in 1966 when the Bendix Corporation donated 175 acres and the Studebaker Clubhouse to the St. Joseph County Parks and Recreation Board. Downhill and cross-country skiing, as well as tubing, were popular winter activities enjoyed by many. A toboggan track was also built, but it was too dangerous and was never opened to the public. (Courtesy of St. Joseph County Parks.)

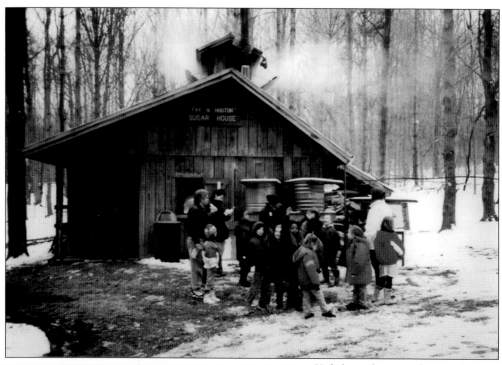

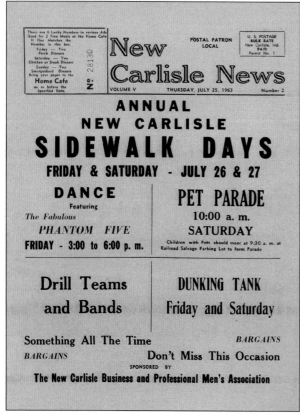

Kids learn how maple syrup is made at the Sugar House at Bendix Woods County Park. Bendix Woods has been host to Sugar Camp Days for over 30 years. A favorite family tradition, the event draws hundreds of people each year to enjoy a pancake breakfast, go on hayrides, and learn how maple syrup is made. Besides this popular program, the park is host to many other nature-related programs and events. (Courtesy of St. Joseph County Parks.)

Historical Days began as Sidewalk Days in the 1950s and was sponsored by the New Carlisle Business and Professional Men's Association. Downtown merchants participated by having special sales and promotions. This front-page ad from the 1963 *New Carlisle News* advertised the two-day event, which featured a pet parade, dance, dunk tank, drill teams, and bands. (HNC.)

The first Historical Days celebration occurred in 1973. It was expanded from the earlier Sidewalk Days events and was eventually taken over by the Hill and Dale Men's Club in 1978. The event featured food vendors, crafts, and antiques as well as many activities and events, such as a parade, dances, musical entertainment, helicopter rides, softball and horseshoe tournaments, a beer garden at Black Cat Lanes bowling alley, Civil-War re-enactments, dunk tank, rides, games, and historic home tours. The photograph above shows a large crowd of people at Memorial Park enjoying the festival. The photograph below shows the Civil War re-enactors during battle. The re-enactments drew huge crowds to Bourissa Hills Park. Today the festival continues under the name of Hometown Days. (Above, courtesy of Dan Schumaker; below, HNC.)

Christmas in New Carlisle is a popular event that started in 1994. The event is always held the Sunday after Thanksgiving; it features a craft show and pictures with Santa. This is followed by a lighted Christmas parade in the evening enjoyed by hundreds of people. After the parade, cookies with Santa are offered at the fire station. The event is sponsored by the Christmas in New Carlisle committee. (HNC.)

The Heritage Harvest Fair is an 1800s living-history fair that began as an annual event in 1990. The fair features open-fire cooking and life-skills demonstrations, such as candle dipping, chair caning, basket weaving, and blacksmithing. Musical entertainment, kids' games, and horse and wagon rides are featured as well. The event is sponsored by Historic New Carlisle, Inc. (HNC.)

Ten

SERVING THE COMMUNITY

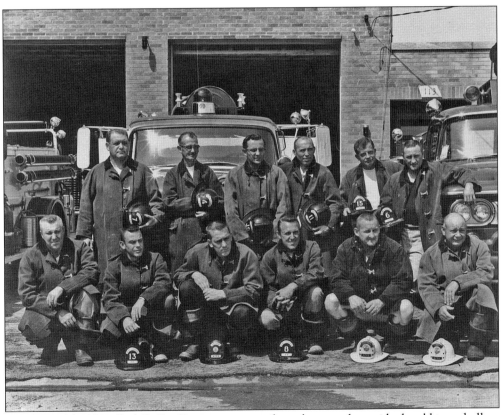

Members of the New Carlisle Fire Department pose for a photograph outside the old town hall on Arch Street. Pictured are, from left to right, (kneeling) Norm Raabe, Darle Hoover, Tom Clark, Dwain Kern, Carl Zahl Jr., and Leon "Ike" Kelley; (standing) James Kring, Carl Ray, Merle Mann, George Blackston, Willie Wilhelm, and John Horvath. (HNC.)

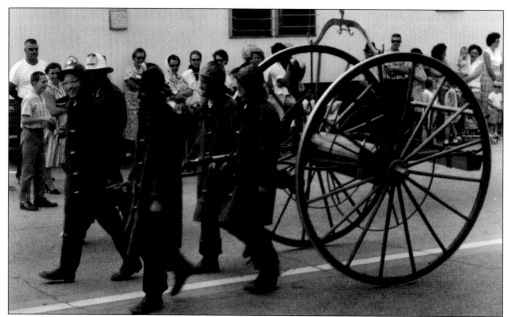

New Carlisle firemen pull the original hose cart down Michigan Street during a parade. In 1870, a group of citizens realized the need for fire protection and a two-wheel hose cart was purchased. The first fire department was formed in 1880 and was known as the New Carlisle Hose Company No. 1. A rich tradition of volunteer firefighters continues to serve the community. (HNC.)

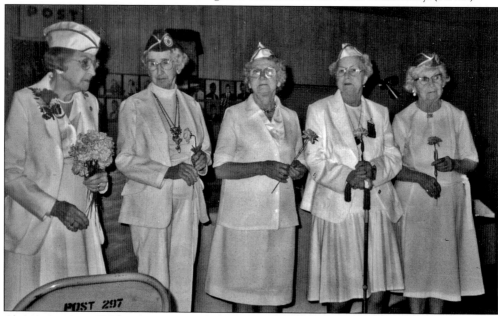

Charter members of the Mothers of World War II, Inc. of New Carlisle, Unit No. 126, commemorated their organization's 40th anniversary in the American Legion Post 297 on May 20, 1984. Pictured from left to right are Viola Gay, Bonita Humphrey, Ruth Kern, Gladys Tolmen, and Lucy Miller. The organization's mission was to aid veterans and their families, including the establishment of a rehabilitation program for hospitalized veterans and loaning hospital equipment for in-home use. It also supported three state veterans hospitals. (Photograph by Mary Ann Swope.)

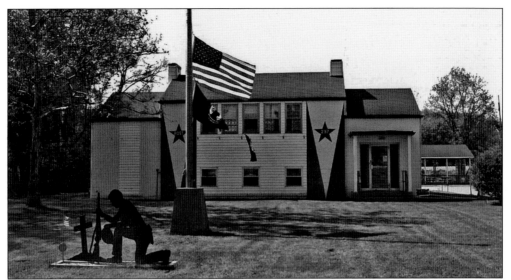

The American Legion Post No. 297 was first organized after World War I as the Swanson Post in memory of James Swanson. A new post was built in 1949. Through the years, American Legion has provided a brotherhood for fellow veterans. It offers annual programs that benefit the community in a variety of ways. Members place flags at cemeteries, hold funeral services for veterans, and participate in many patriotic events. (Photograph by Everett Dobbins.)

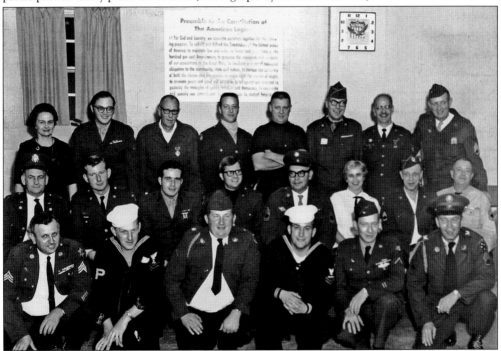

American Legion members pose for a photograph during a 1967 dinner. Pictured are, from left to right, (first row) Walter Grabarek, Ray Sisk, unidentified, Don Conn, Don Loree, and Dave Stickler; (second row) Bob Jones, Augie Maurer, Bob Tierney, three unidentified, Ralph Smith, and unidentified; (third row) unidentified, Dale Borders, Cecil McCollum, Kenny Kratz, Rich Tolmen, two unidentified, and Ralph Ackenhusen. (Courtesy of the American Legion Post No. 297.)

The New Carlisle Lions Club was formed in 1939. The first project of the club was in 1940 when it built new street signs for the town. Installing the College Street sign (above) are, from left to right, Joseph Ekstrom, Don Ross, and Pat Murphy. Another early project was the construction of the football field in 1956. Pictured below are, from left to right, Ray Nixon, Claudis Smith, John Anderson, unidentified, Carl Ekstrom, and William Palm manning the snack bar. The Lions Club has supported the community in many ways over the years. Just a few of its past projects include the purchase of playground equipment for local schools and parks, donations to the fire department, and participation in local food and toy drives. The New Carlisle Lions Club celebrated its 70th anniversary in 2009. (Both courtesy of the New Carlisle Lions Club.)

Members of the Order of the Eastern Star are, from left to right, (front row) unidentified, Morene Bailey, Florence McMullin, Lucille Gyorgyi, Fern Walker, Jean ?, Ruth Holman, and Mildred Rogers; (back row) Ruby Jones, Sue Murphy, Mary Colburn, Harris Taylor, Martha Holaday, Myron Colburn, Mary Taylor, Mary Clendenen, Iva Fisher, Frank Fisher, and Denise Cooper. (Courtesy of the Order of the Eastern Star.)

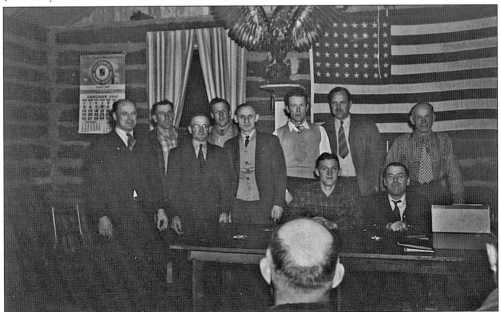

Members of the New Carlisle Conservation Club are pictured in 1947. From left to right are (sitting) Carr Rodgers and unidentified; (standing) Ernie Meyers, Dewey Bickel, Orsen Bunton, John Clark, Carl Zahl Jr., John Hensell, unidentified, and Virgil Rodgers. The New Carlisle Conservation Club was located on Timothy Road, situated on a hill in the woods overlooking wetlands. The clubhouse was used for a variety of community activities over the years. (Courtesy of the Horvath family.)

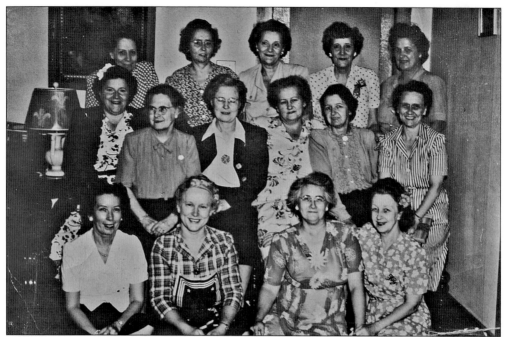

Delta Beta Phi Sorority sisters pose for a photograph around 1945. Pictured are, from left to right, (first row) Grace Burden, Florence Bates, Bertha Shank, and Florence Daum; (second row) Ivy Mueller, Jane Ellis, Bunn Zigler, Sue Murphy, Eva Sharp, and Prudence Davis; (third row) Bess Smith, Mary Danielson, unidentified, Magdaline Madden, and Pauline Ross. (HNC.)

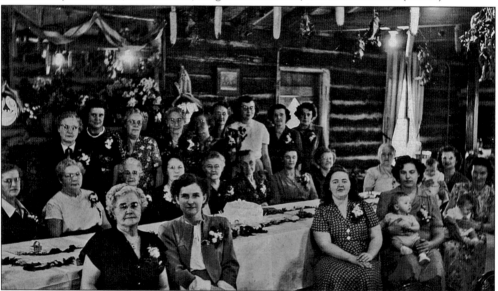

Bootjack Community Club members are pictured in 1948. From left to right are (first row) Grace Bartmess, Esther Wykoff, Ruth Kelley, Maxine Kelley with son Norm, and Vera Bartmess with niece Connie Merley; (second row) Gusta Bennitt, Fanny Bennitt, Mary Taylor, Edna Hinman, Margie Jones, Etta Dudley, Margaret Kelley, Mabel Dudley, Virginia Shead, and June Merley with daughter Bonnie; (third row) Bunn Zigler, Virginia Hollett, Bertha McDonald, Mrs. Hollett, Glennie Clark, Mary Kelley, Barbara Bealor, Mary Alice Horvath, and Rose Horvath. (Courtesy of Mary Alice Horvath.)

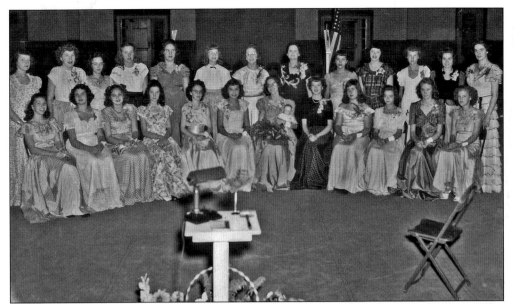

The Order of the Rainbow for Girls was an active youth organization from the 1940s to 1970s. Pictured around 1947 are, from left to right, (first row) Marilyn Jones, Sharon Poland, Jean DuBois, Donna Phillips, Shirley Kleine, June Swanson, Ruth Ann Smith, Barbara Gelow, Patsy Clark, Betty Bingaman, Charlotte Alm, and Bonnie Rogers; (second row) Helen Tolmen, M. Sarber, Joanne McPherson, Grace Rader, America Headley, Frances Gay, Judy Kleine, Muriel DuBois, Audrey Mell, Louise Tolmen, Joyce Anderson, Jane Ann Luzadder, and Jane Ann Nickerson. (Courtesy of Judy (Kleine) Brown.)

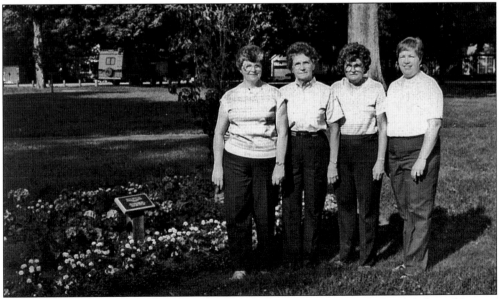

Pictured from left to right are Margaret Calhoun, Mary Alice Horvath, Sadie Melady, and Bonnie DeMeyer proudly standing next to one of their many community projects. The beautiful flower garden at Memorial Park was planted in the summer of 1985 and continues to be maintained by sorority members. The Kappa Rho chapter of New Carlisle was granted a charter in Delta Theta Tau Sorority on April 28, 1957. (Courtesy of Delta Theta Tau Sorority.)

The Hill and Dale Men's Club was officially chartered on January 14, 1977. This group of young energetic men did much to benefit the community. The annual production of Historical Days beginning in 1978 was perhaps the most prominent club activity, but many other activities were carried out, such as the annual Outstanding Citizen's Award, fishing trips for residents of Miller's Merry Manor, Christmas caroling through town, and a Christmas food drive. The first murals on the viaduct wall can also be attributed to the club. Pictured at left is Fay Hooton receiving an Outstanding Citizen award from Hill and Dale Club member Dan Schumaker. Club members put in many hours constructing the softball diamond (below) and building Harris Street leading to the field. (Both courtesy of Dan Schumaker.)

ABOUT HISTORIC NEW CARLISLE, INC.

Historic New Carlisle, Inc. was organized in 1989 as a not-for-profit historical society. The group first met in the homes of members and later at the library. Eventually the group was able to get a storefront location in downtown New Carlisle. Members began to collect items such as old photographs, newspapers, scrapbooks, and other objects of interest related to the history of New Carlisle.

The group started annual projects early on, such as the Heritage Harvest Fair, an 1800s living-history fair held the first weekend in October. The group also began a tree reforestation project and has planted over 65 trees in New Carlisle lawns since the program began. In 1998, the group took on its most daunting task and purchased the Old Republic, a landmark home that had been vacant for nearly 30 years. Through grants, loans, donations, and many volunteer hours, the house was rehabilitated and now serves as HNC's office and local history museum and also houses the Inn at the Old Republic, which contains four bedrooms on the second floor. The house is also available to rent for special events such as anniversary and graduation parties, bridal and baby showers, small weddings, and meetings.

The organization has grown over the last 20 years to include 400 members who generously support HNC's programs and events as well as the ongoing maintenance of the Old Republic. Many activities have been added, such as annual historic preservation awards, a Breakfast with Santa, Bunny Breakfast, teas, dinners, and other fundraising activities. Historic New Carlisle, Inc. strives to infuse the New Carlisle community with a greater awareness and appreciation of history and historic preservation. Activities such as walking tours, architecture camps for kids, and educational programs about the history of New Carlisle aim to do just that.

www.arcadiapublishing.com

Discover books about the town where you grew up, the cities where your friends and families live, the town where your parents met, or even that retirement spot you've been dreaming about. Our Web site provides history lovers with exclusive deals, advanced notification about new titles, e-mail alerts of author events, and much more.

Arcadia Publishing, the leading local history publisher in the United States, is committed to making history accessible and meaningful through publishing books that celebrate and preserve the heritage of America's people and places. Consistent with our mission to preserve history on a local level, this book was printed in South Carolina on American-made paper and manufactured entirely in the United States.

This book carries the accredited Forest Stewardship Council (FSC) label and is printed on 100 percent FSC-certified paper. Products carrying the FSC label are independently certified to assure consumers that they come from forests that are managed to meet the social, economic, and ecological needs of present and future generations.

FSC
Mixed Sources
Product group from well-managed forests and other controlled sources

Cert no. SW-COC-001530
www.fsc.org
© 1996 Forest Stewardship Council

Find *Your* Place in History.